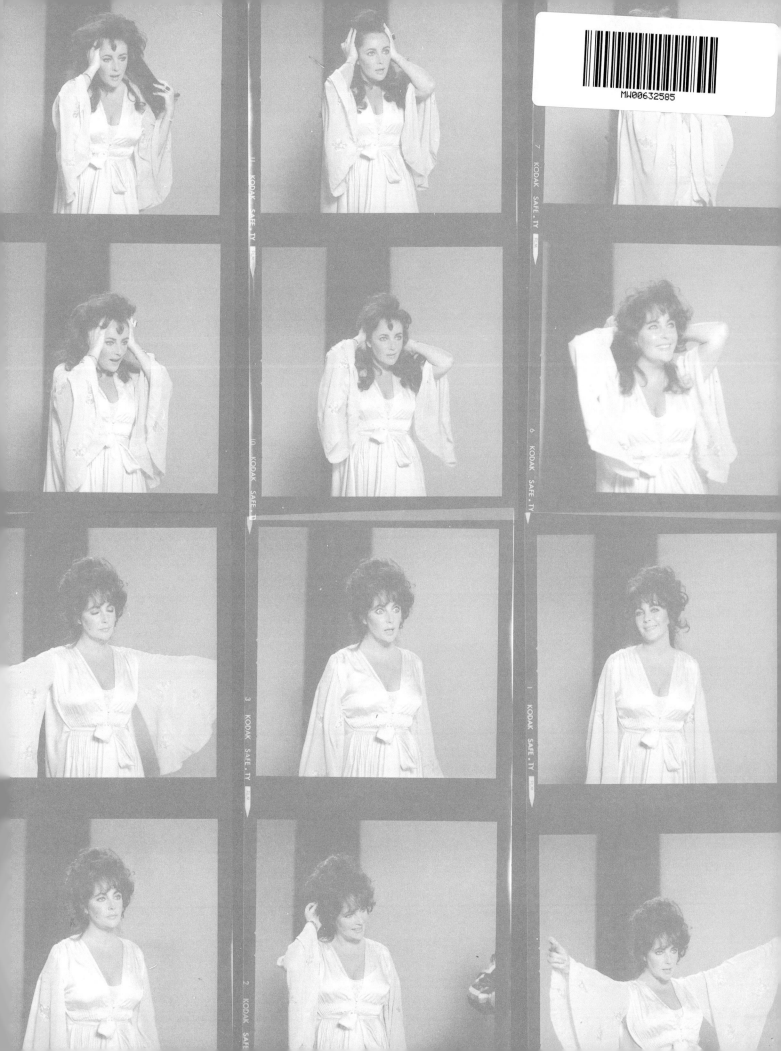

ELIZABETH TAYLOR

I love you so!
Elizabeth

Elizabeth Taylor

THE QUEEN AND I

Gianni Bozzacchi

THE UNIVERSITY OF WISCONSIN PRESS

The University of Wisconsin Press
1930 Monroe Street
Madison, Wisconsin 53711

www.wisc.edu/wisconsinpress/

3 Henrietta Street
London WC2E 8LU, England

Printed and bound in China
by C&C Offset Printing Co., Ltd.
Designed by Kristina Kachele

Library of Congress Cataloging-in-Publication Data
Bozzacchi, Gianni.
Elizabeth Taylor : the Queen and I /
Gianni Bozzacchi.
ISBN 0-299-17930-3 (cloth: alk. paper)
1. Taylor, Elizabeth, 1932—Portraits.
I. Title.
PN2287OT18 B69 2002
791.43′028′092 2002002805

This book is dedicated to my wife, Kelley Vander Velden,
and my daughter, Rhea Bianca Bozzacchi.

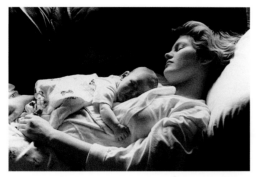

KELLEY AND RHEA, FIRST DAY HOME

After losing her mom at the end of November 1998, Rhea went back to school.

It had been for her and me a sad Christmas holiday. When leaving the house, she asked me,

Where is Mommy now?

My answer was,

She's here with us. She's here.

And I pointed to the sky. We remained in silence and walked to the end of our property.

Before getting into the school bus, she said,

Dad, you're such a good photographer,
why don't you show me where Mommy is now?

I shot and immediately printed this double-exposed, superimposed image:

THE SKY, KELLEY, AND THE RAINBOW

When she came back home from school and found the framed picture in her room,

she looked at me with shining eyes and said,

Thanks, Dad.

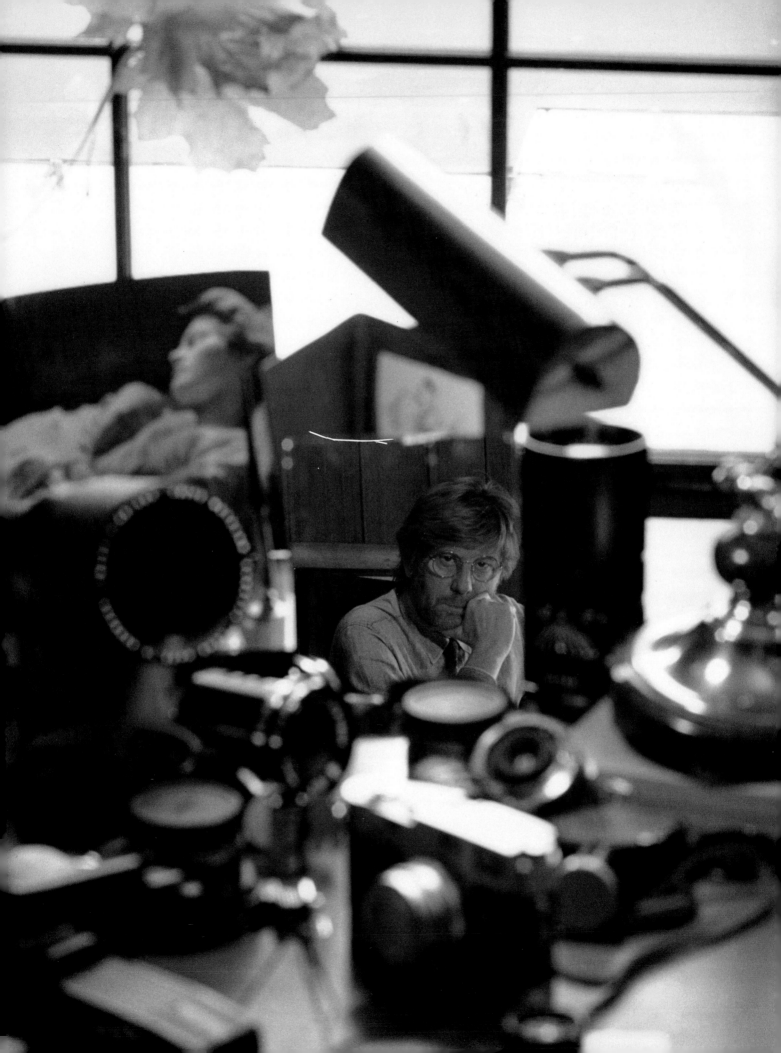

IF ONLY THE MECHANICAL EYE COULD WHOLLY SUCCEED

IN CAPTURING WHAT I PERCEIVE WITH THE NAKED EYE,

I WOULD BE SATISFIED.

Gianni Bozzacchi, 2002

CONTENTS

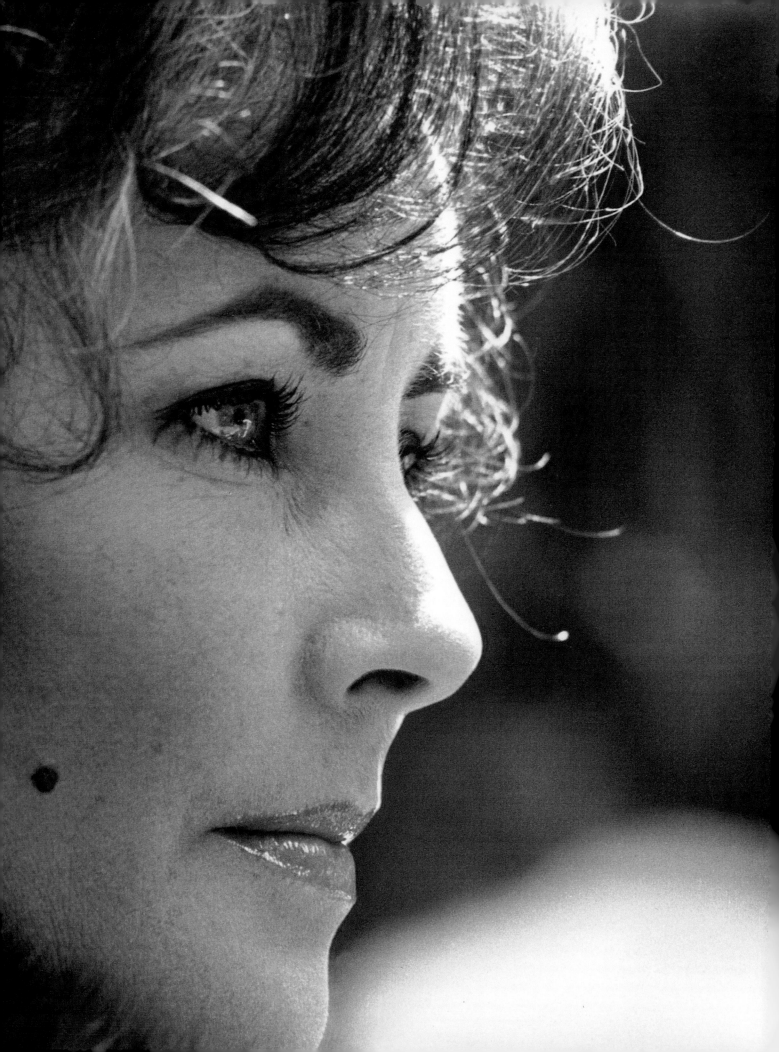

INTRODUCTION

I look at these pictures and see how much I have changed. My photographs have not

changed, but I have, and I've changed in very basic ways.

When I shot these pictures, I was living in a jet-setter world to which I did not belong.

The life I lived was a fairy tale, but it was not always wonderful for me because I lived in

fear that the stars I was photographing would find me out. I was afraid they would dis-

cover that I didn't know what I was doing. I came from an artisan family and could never

have imagined that I might ever live among such glamorous people.

My father, Bruno, was the great photographer in the family, although he worked in total

obscurity for a private institution called the Patologia del Libro—literally, Pathology of

the Book, but meaning the Hospital for Books—in Rome. His work was restoring and pre-

serving old manuscripts and photographs, including some genuine historical treasures,

such as the letters of Machiavelli and Leonardo da Vinci, and the original quotations of

Chairman Mao. I started my career in my father's shadow, under the glow of ultraviolet and infrared rays, learning how to refine and retouch valuable images. I learned photography from chemicals and science. You might say I started my career backward, evolving from the scientific to the artistic.

But my father always worked too hard for a meager living. I didn't want to live in the dark of a darkroom. Much to his displeasure I left school and for a time lived a restless carefree life in the light. Before I became well known as a photographer, in fact, I was well known as a speed racer on the Italian highways. I was so well known that newspapers wrote articles about me, and patrons in bars placed bets on how fast I could drive the four hundred miles from Rome to Milan (my best time was three hours and forty-five minutes).

At the same time, I had learned well from my father and possessed skills that I put to use earning a good salary retouching and printing archaeology photographs for Roloph Beny and tourism photographs for Ivan Cichanovic, along with high-fashion photographs for Johnny Moncada and film and fashion layouts for the Pierluigi Agency. These people were the best in their fields in Italy, and at the time Italy's work was all I knew. I discovered later on that they were the best in the world. Without any modesty I can say that I was their expert at printing and retouching, even as a very young man. Because I was an early master at retouching, when I became a photographer I would scorn retouches in the laboratory and do all my retouching with available light before I took the photograph.

Obviously, I lived a conflicted life as a young man. After a terrible car accident in September 1964, when the Giulietta Alfa Romeo GTA I was driving crashed at 230 kilometers an hour and I was plunged into a coma for three months (on and off), I realized that God had sent me a message. God and my father—because my relationship with my

father had been pushed to its negative limits. He was always furious that I was doing nothing with "his talent," as he might say, meaning the talent I had inherited from him.

After recovering from my accident, while visiting my sister Ofelia in Florence, I took a little camera in my hand and had a conversation with it. My old camera told me: "You need to change your life, and the first thing you have to do is buy a better camera!"

Combining my racing mania with my new ambition, for three months I transported newspapers from the printer to distributors, picking up the day's edition in Milan at midnight and delivering it to some five hundred newsstands in Rome by six A.M. the next day. At that time there was a law in Italy that a plane could not take off after midnight, and the train was too slow to arrive by dawn, so a friend and I took on this perilous task of bringing the fresh headlines to the people of Rome in time for their early-morning cappuccino. The daredevil job paid well, however, and I can honestly say that to buy decent photographic equipment, I risked my life every night.

The money I earned bought a Hasselblad, two Leicas, various lenses, and a light meter. I went to work for Pierluigi Praturlon, Frank Sinatra's and Federico Fellini's favorite photographer, in 1965, initially stuck in the darkroom but quickly graduating to film and fashion assignments. Pierluigi had a well-organized operation, the first and biggest journalistic agency of its kind, and I found myself in the center of a new world. One of Pierluigi's sidelines was hiring his agency out for "special photography" of glamorous stars on exotic film locations.

This led to the profession that would really consume me for the next twelve years. The Academy of Sciences, Arts and Letters of Wisconsin, the state where I now reside, considers me to be the last curator of the photographic image. What they mean is that I'm one of the last, if not the last, of the celebrity personal photographers. Today, television

delivers something they call news—but it really isn't. All the networks now distort or glamorize the news in order to market and sell products via their commercials. But when I was a photographer for magazines like *Look, Life, Paris Match,* and many others of the same caliber, the photographer was the one who delivered the world's news, and we let our images tell the essence of the story. We shot what we saw and allowed the general public to react to that image, without distortion or interference.

Because I took that mission seriously, there were three maxims I strictly adhered to as a photographer: I worked to satisfy the subject, the client, and then myself. So much of the photography we see everywhere now is really about the art of manipulation. Commercial clients often retouch a photographer's work, changing everything from the subject's hair color to the wardrobe. Photographers themselves shoot, erase, and shoot again; they put the image into a computer and alter whatever they want. When I was shooting Elizabeth and other stars, though, the photographer made his crucial choices as he shot, based on the right film, the right ASA, the filters, and the settings. The most important decision had to do with light, because that's how you created intensity. By maneuvering the subject, the diaphragm, and the speed of the camera, you could create a character, or reveal a woman's beauty. In the darkroom, you gave life to the image you shot by joining chemistry to physical science.

ROME, 1967. IF YOU PROVOKE THE SUBJECT WITH YOUR EXPRESSIONS, THE CAMERA DISAPPEARS AND THE SUBJECT RELAXES.

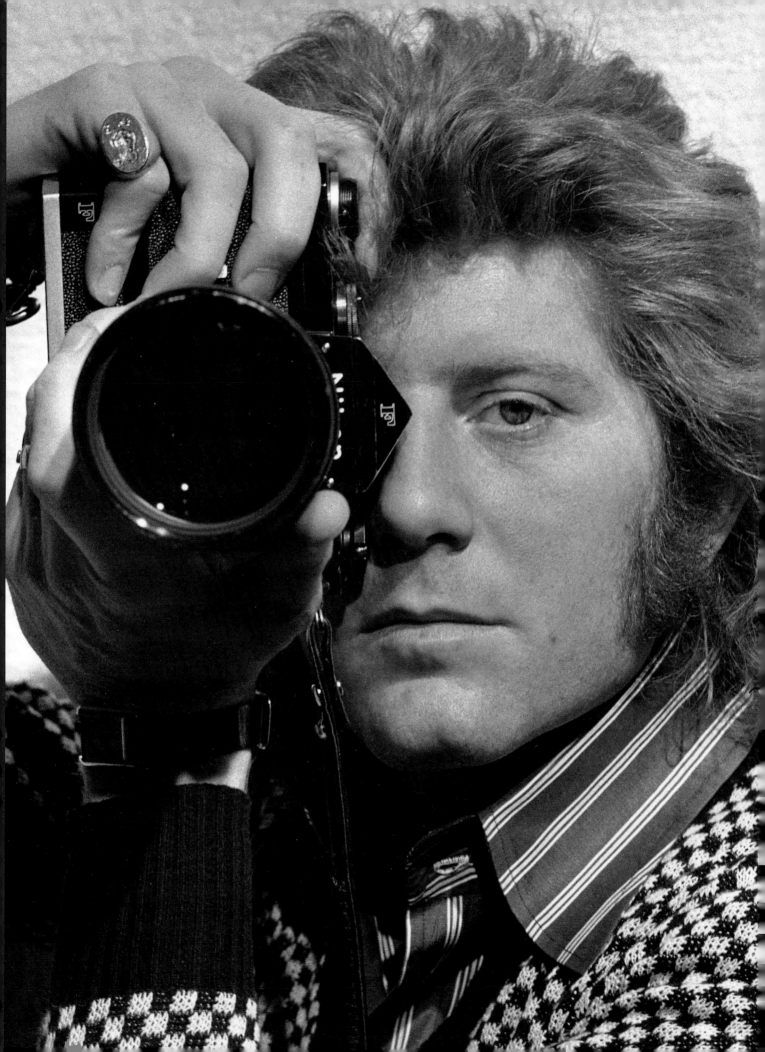

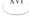

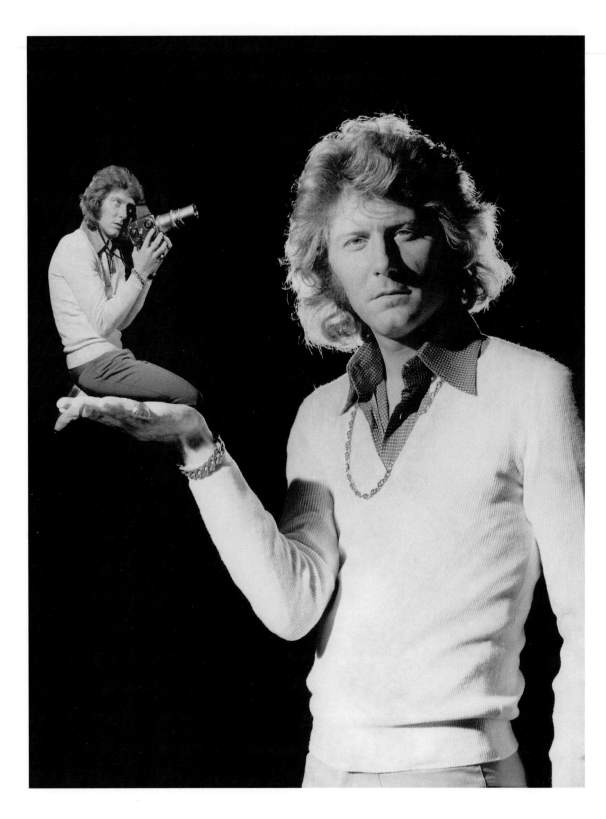

LONDON. MY FIRST SELF-PORTRAIT, A DOUBLE EXPOSURE TAKEN TO ACCOMPANY "THE KING OF CAMERA," AN ARTICLE IN THE ENGLISH PAPER *The Daily Mirror.*

opposite
WALES, 1970. PHOTOGRAPH BY MICHAEL WILDING, ELIZABETH TAYLOR'S SON AND MY ASSISTANT DURING THOSE YEARS, PUBLISHED MANY TIMES AND WITH VARIOUS CAPTIONS: "THE JET SET PHOTOGRAPHER," "THE PHOTOGRAPHER OF THE DIVAS," "A SEX-SYMBOL," ETC., ETC.

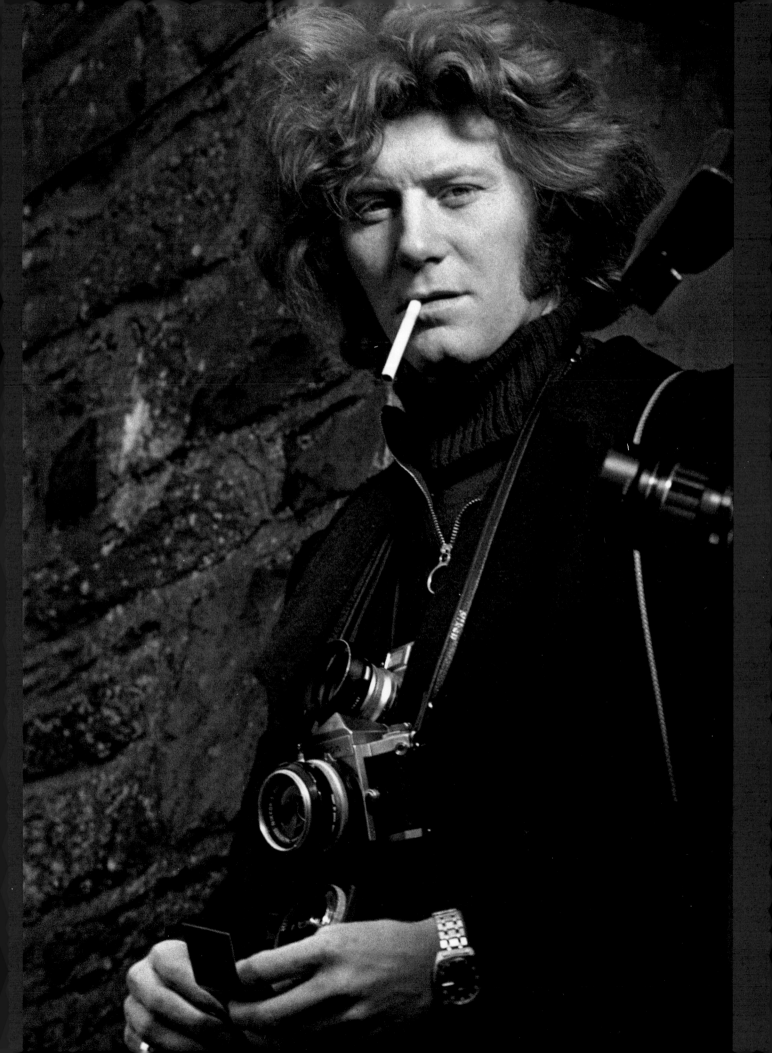

Liz e Burton in gran gala alle

1 **Pauperthuis (Parigi).** Liz Taylor e suo marito Richard Burton hanno fatto da testimoni a due giovani amici che si sono uniti in matrimonio in un villaggio ne pressi di Parigi. Ecco i due famosi attori ai lati degli sposi: la parrucchiera di Liz, Claudie Ettori e il fotografo Gianni Bozzacchi. Liz, che considera quasi un figlia la giovane parrucchiera, ha voluto fare le cose in grande: ha indossato un magnifico abito di Dior, d'organza color giunchiglia, e ha voluto che le sue bambine Liza e Maria, facessero da damigelle alla sposa. Al contrario della elegantissima moglie, Richard Burton appare, come al solito, piuttosto spettinato e trasandato

SAINT, FRANCE, JUNE 22, 1968. NEWSPAPER CLIPPINGS OF MY FIRST WEDDING CEREMONY WITH EXCEPTIONAL WITNESSES, E. T. AND R. B., MY PARENTS, AND GUESTS. MORE THAN A HUNDRED PAPARAZZI CAME.

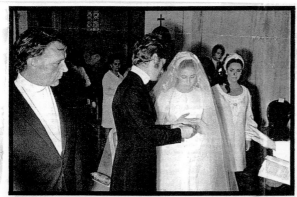

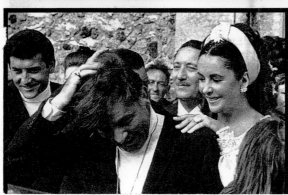

PER L'ALBUM DEL-
LA SPOSA. Pauper-
thuis. Un momento impor-
tante: Liz si fa ritrarre con
la sposa per la foto ricor-
do.' L'attrice è molto affe-
zionata a Claudie, e glie-
l'ha dimostrato, fra l'al-
tro, regalandole l'abito nu-
ziale, che porta la firma
illustre di Christian Dior.
A sua volta Liz è inter-
venuta alla cerimonia con
uno splendido abito rica-
mato color giallo paglia,
anch'esso firmato da Dior.

UNA FOTOGRAFA
D'ECCEZIONE. Pau-
perthuis. La festa è finita.
Prima di andarsene, Liz
non rinuncia a fare una
istantanea alle sue bambi-
ne. Liza ha 11 anni, ed è
nata dal matrimonio di Liz
con Mike Todd. Maria ha
7 anni, ed è figlia adotti-
va dell'attrice. Liz ha al-
tri due figli: Michael (15
anni) e Christopher (13
anni), avuti da Michael
Wilding. La Taylor ha
36 anni; Burton ne ha 45.

top left
MY WEDDING.

middle left
MY BROTHER-IN-
LAW, ROBERTO
SEVERI, R.B.,
MY FATHER,
BRUNO, AND
E. T.

top right
E. T. PHOTOGRAPHS
LIZA TODD AS
MARIA BURTON
LOOKS ON.

...68 (Francia). Il classico gruppo fotografico degli sposi con i testimoni (Liz Taylor e Richard Burton), con il paggetto (seduto a terra) e con le due damigelle d'onore
...decenne Liza Todd, figlia di Liz e del suo quarto marito, Mike Todd, e Maria Burton, di sei anni, l'orfanella tedesca che i Burton hanno adottato quattro anni fa). Liza
...a bambina a sinistra e Maria quella a destra. Liz Taylor ha donato alla sposa lo splendido abito nuziale creato da Marc Bohan e costato quasi due milioni; dono di
...ze di Richard Burton è stata la sua nuovissima Rolls-Royce. Lo sposo ha donato alla sposa una creazione di Bulgari: un anello con zaffiro a losanga bordato di brillanti.

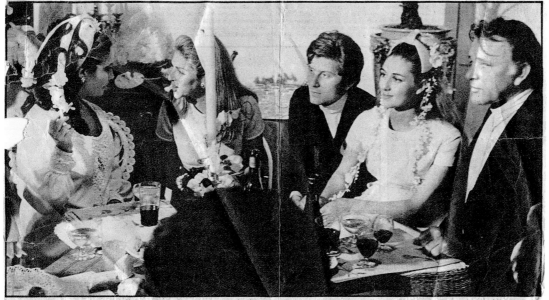

...Saints (Francia). Un momento del rinfresco. Attorno alla tavola si notano, da sinistra, Liz Taylor, la baronessa Rothschild, i due sposi e Richard Burton. Gli sposi hanno
...alloggiato per un giorno nel favoloso « Manoir de Chaubuisson » (uno degli alberghi più belli del mondo) e sono poi partiti per la luna di miele, che trascorreranno tra
...Roma, Amalfi, Capri, Sorrento e Ischia. Claude e Gianni sono ormai di famiglia in casa Burton e ricevono per le loro prestazioni uno stipendio eccezionalmente alto. Liz
...è affezionata a Claude al punto di volerla sempre accanto a sé e di presentarla a tutti come « mia sorella »; inoltre, generosa com'è, le offre di continuo costosissimi regali.

bottom MARIE ELAINE DEROTHSCHILD WAS ONE OF MANY UNINVITED GUESTS.

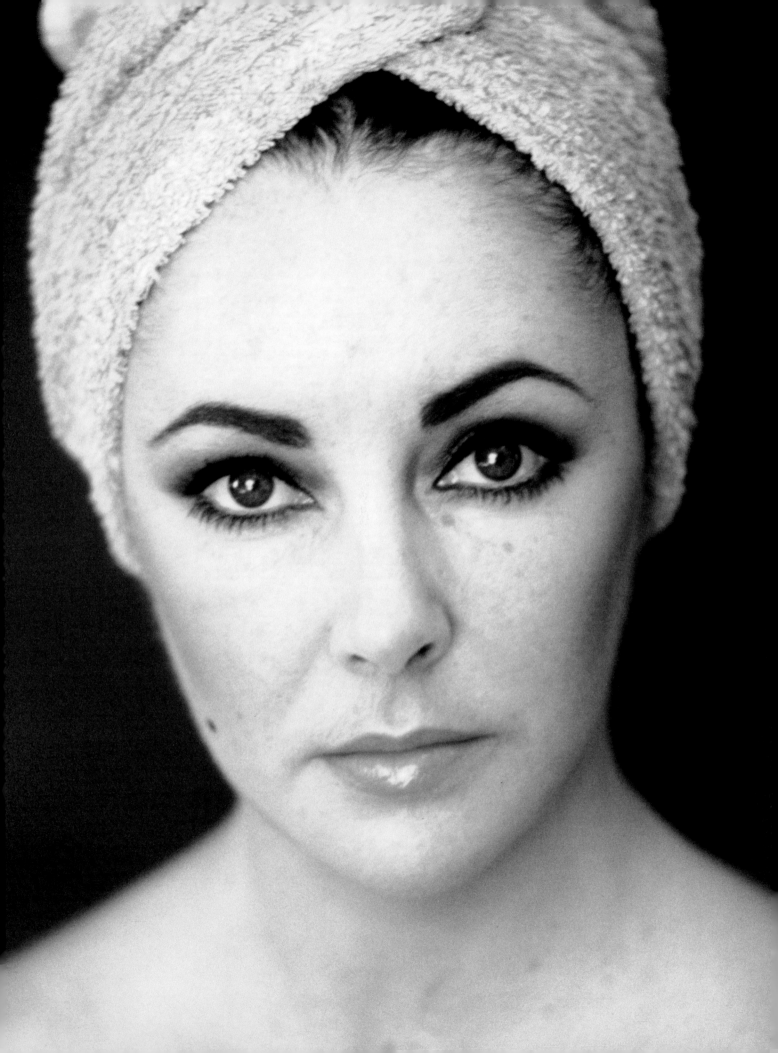

Part 1

E L I Z A B E T H A N D I

learned my craft slowly, but well. After a period of adjustment with Pierluigi, I was entrusted with the most important clients. In November 1965 I was sent to Africa to handle the "special photography" for *The Comedians*, a film based on the Graham Greene novel, which starred Peter Ustinov, Alec Guinness, Richard Burton, and Elizabeth Taylor. After a stop in Paris for my visa, I arrived after a very long plane trip in the city of Cotonou in Dahomey (now Benin), carrying with me a complete black and white laboratory. At that time, Elizabeth had approval of every photograph, so I had to print all of them on site.

It was in Africa that my life really began its transformation, and where I had a foretaste of the future. I was in the right place at the right time in my career, and I was made to feel special. When I was stopped in the street, girls would reach out to touch my long, bright red hair—I knew I had something that fascinated the natives as well as the film

people. I was young, skinny, different-looking. I had a kind of sex appeal, that's what everybody said—including *Playboy* magazine. Throughout my career as a photographer—maybe still today, though I no longer take photos—that sex appeal was useful.

At the same time my too-youthful appearance did not immediately inspire confidence among the actors. I could tell by how they all watched me warily. Perhaps especially Elizabeth, as the rule was that I could not take a photograph of her without prior permission. Yet I did one day. She noticed and stared at me, but she said nothing. All of the photographs went to her anyway, for her authorization before release.

Cotonou was a memorable experience. So many things happened there, so many adventures. During my stay, there were two revolutions in that country, and the president in office was overthrown each time. Because war is dangerous, I decided to carry a gun, and one night, pretty late, I was going back to the Hotel de la Place when I spotted, through the bushes, someone advancing toward me with a menacing demeanor. My reaction was fast. I pulled my gun, loaded it, and pointed it at the approaching man. It was Marlon Brando. I had almost fired a bullet into him. Can you believe it? There wouldn't have been a *Godfather* or an *Apocalypse Now*.

Marlon was not a member of the cast of *The Comedians*, however, and when I arrived on the set the next day and told everybody that he was in town nobody believed me. A couple of hours later, Marlon showed up to see Elizabeth (they were friends and were going to act together in *Reflections in a Golden Eye*). He made a beeline for her and hugged her in a way that offended Richard, and the two of them proceeded to have a crazy fight. I don't have any photographs of that incident for the good reason that the publicist grabbed my roll of film. In the evening, however, Marlon and Richard got drunk together and everything was forgotten.

It was also in Cotonou that I met my first wife, Claudye Ettori. She was Elizabeth's hairdresser, and it was her first film with Elizabeth as well.

After the filming was completed, Elizabeth summoned me to Nice, France, where she scoured the photographs I had taken, especially the ones I had taken without authorization. She insulted me. "You're really good," she said, "but you're an asshole to have taken these pictures without my consent." Then she confused me further by asking if I would agree to become her personal photographer, traveling everywhere with her and Richard.

Knowing that Claudye and I had been seeing each other, she invited me to take a cruise with her and Richard on their yacht, the *Kalizma* (KAte-LIZa-MAria, after three of Elizabeth's and Richard's daughters). I wasn't sure that I wanted to take the job she had offered, but I did go on the cruise and had my photograph taken with them as we entered a restaurant in San Remo, on the Italian Riviera. Pierluigi, my boss and the owner of the agency that bore his name, saw the published photo and in a jealous pique fired me. "I created you," he said, "and I will destroy you." The truth is, I had become vital to his success and was the most prestigious photographer in his agency. Two years after I left him he went bankrupt.

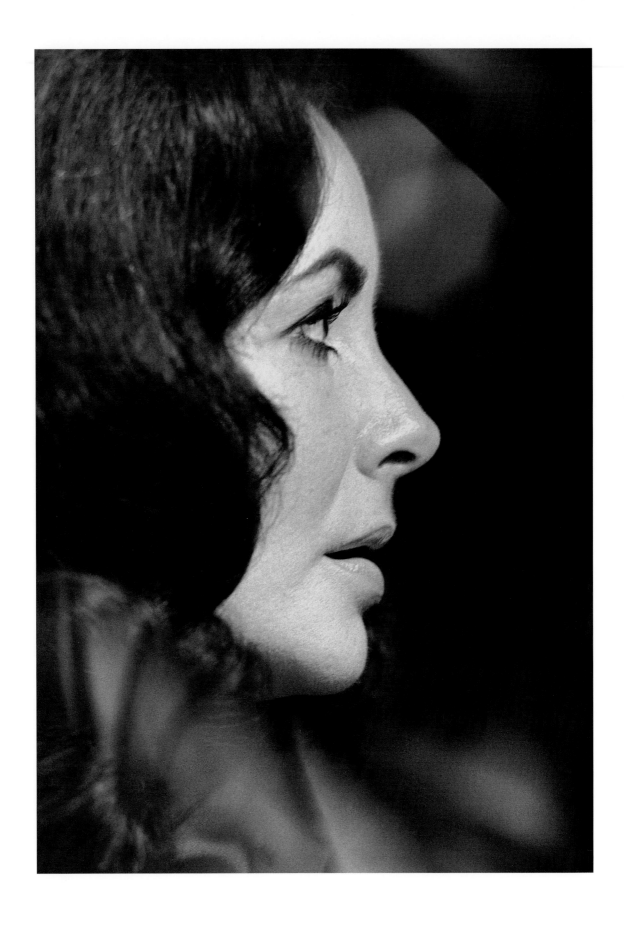

SARDINIA, ITALY. IF BOTTICELLI WERE LIVING TODAY HE WOULD BE INSPIRED BY ELIZABETH.
RIGHT PROFILE OR LEFT, NO DIFFERENCE. BOTH ARE PERFECT, EQUAL, AND EXTRAORDINARY.

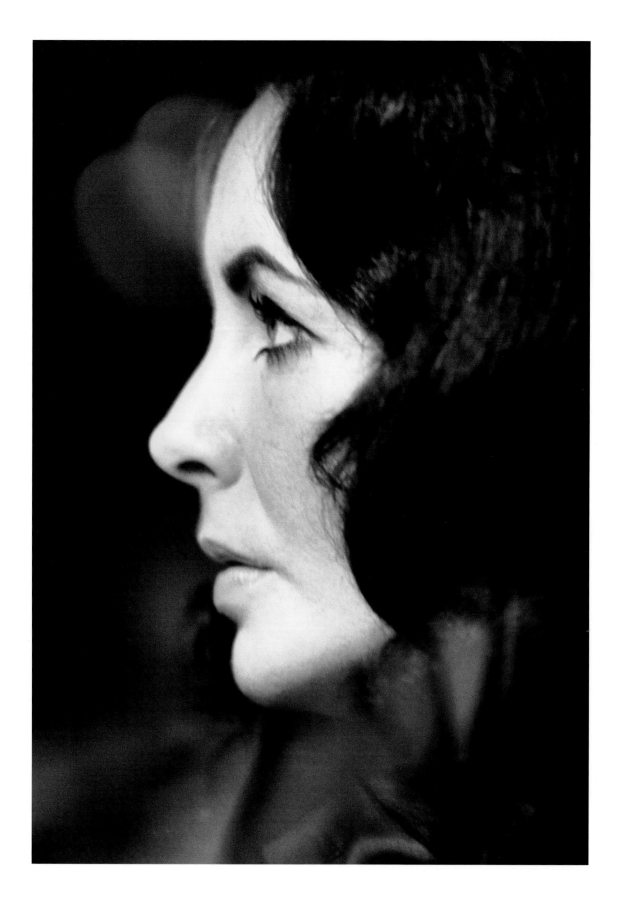

8 CAPRI, ITALY. WITHOUT MAKEUP HER SENSUALITY IS ENHANCED.

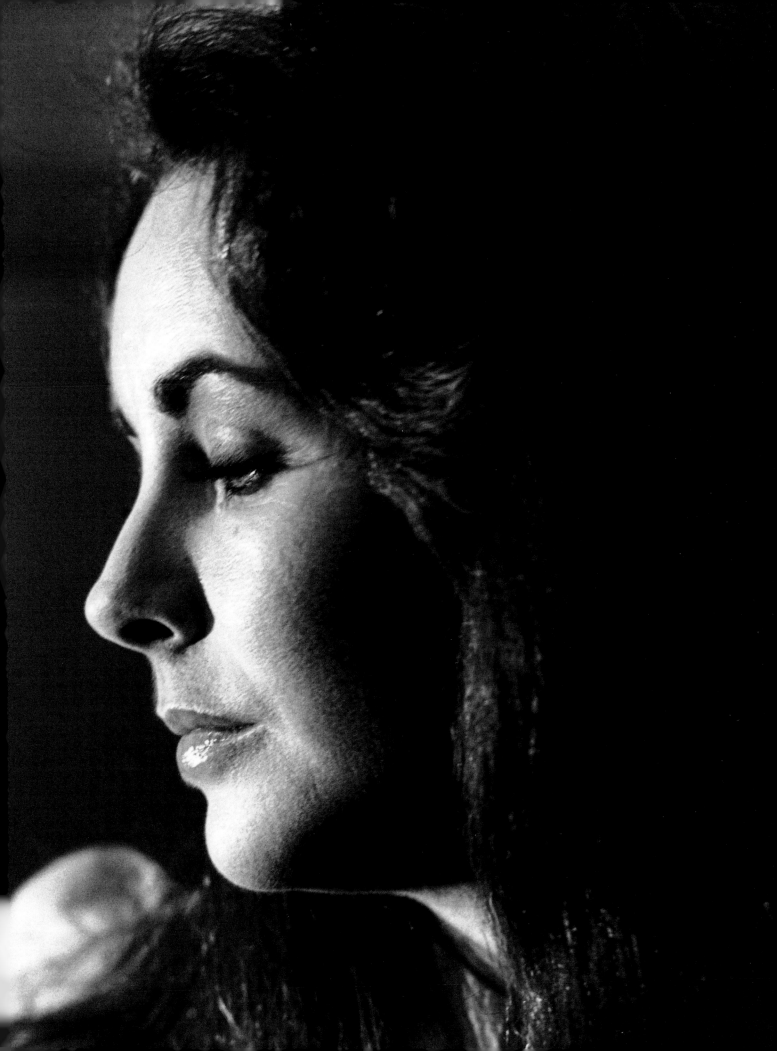

MUNICH, GERMANY. THE UNMISTAKABLE PROOF OF HER BEAUTY—
I SUCCEEDED IN CAPTURING *lo strabismo di Venere.*

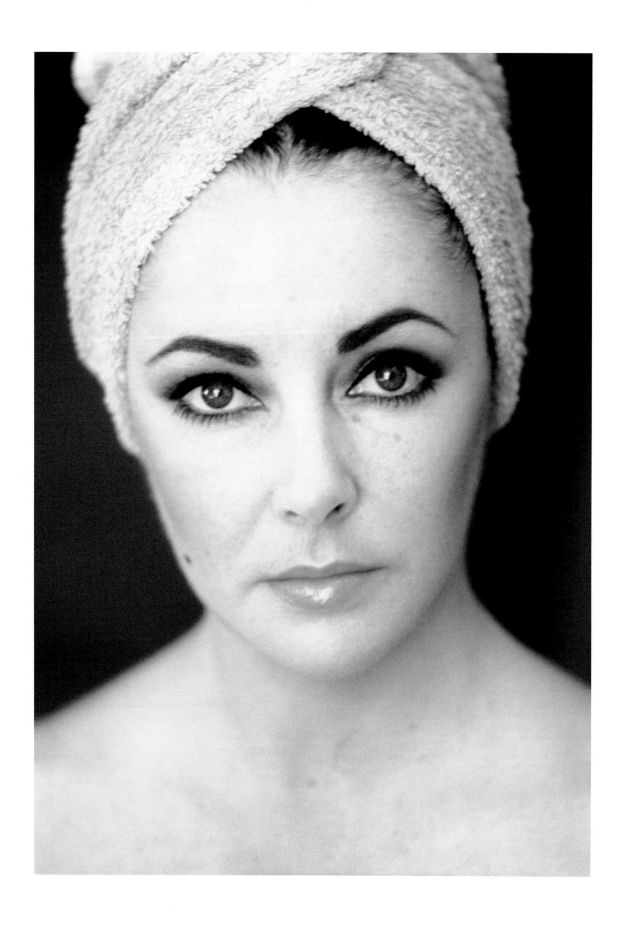

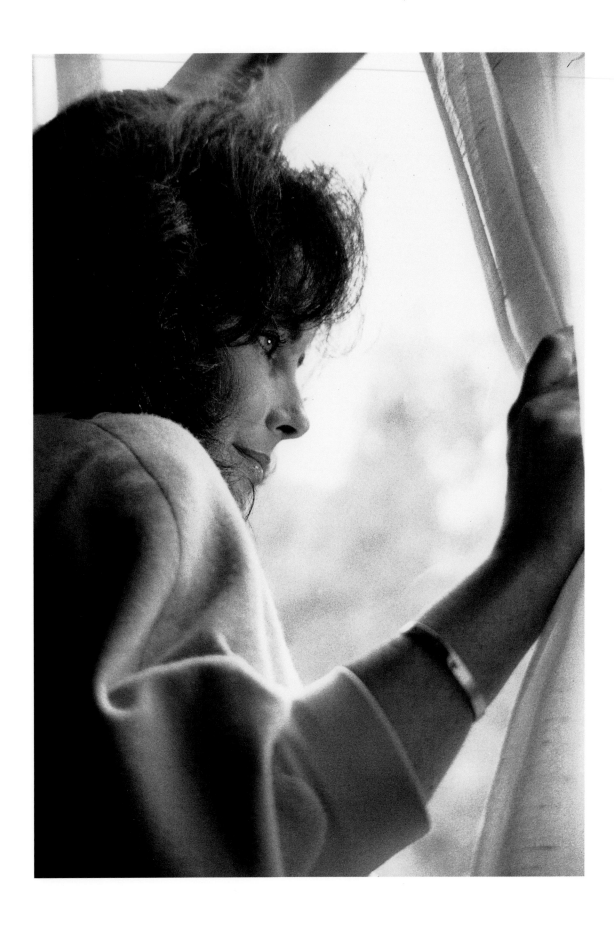

A SLIGHT MOVEMENT OF HER FACIAL MUSCLES, AND A CONTRASTING EXPRESSION FORMS.
NOT EVERYONE CAN DO THAT.

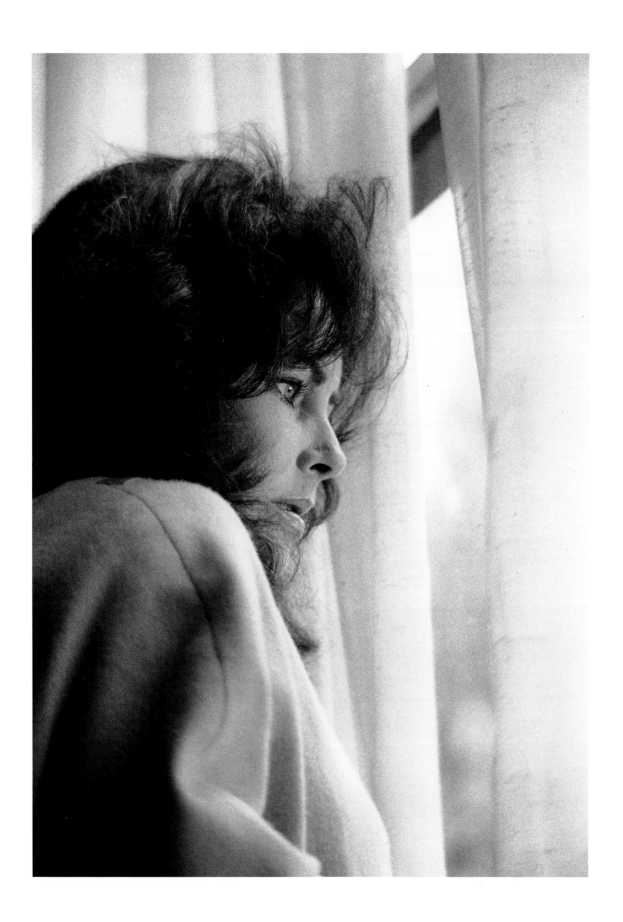

13

14

She always loved animals and they always loved her.
She isn't smiling at me but rather at another animal—Richard.

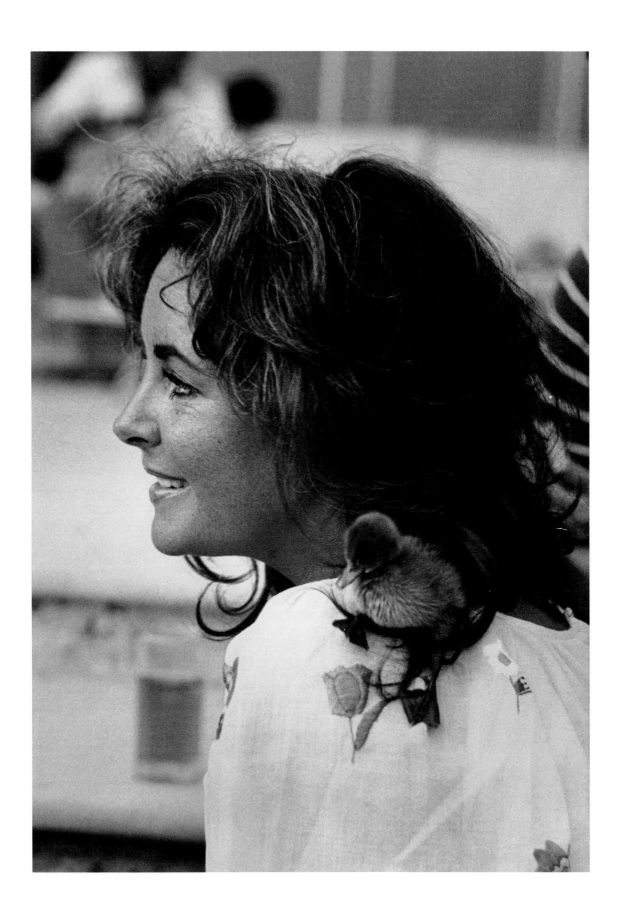

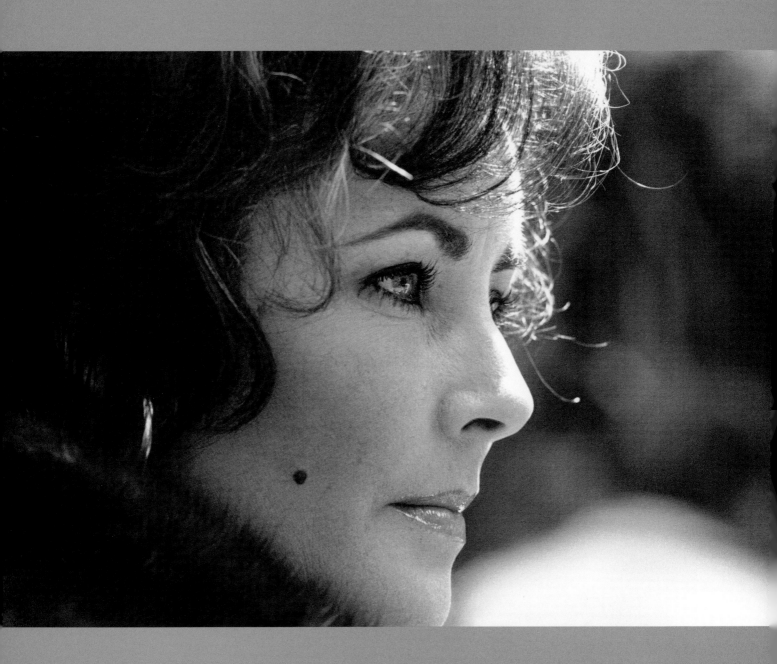

YEARS PASS AND HER FACE REMAINS UNCHANGED

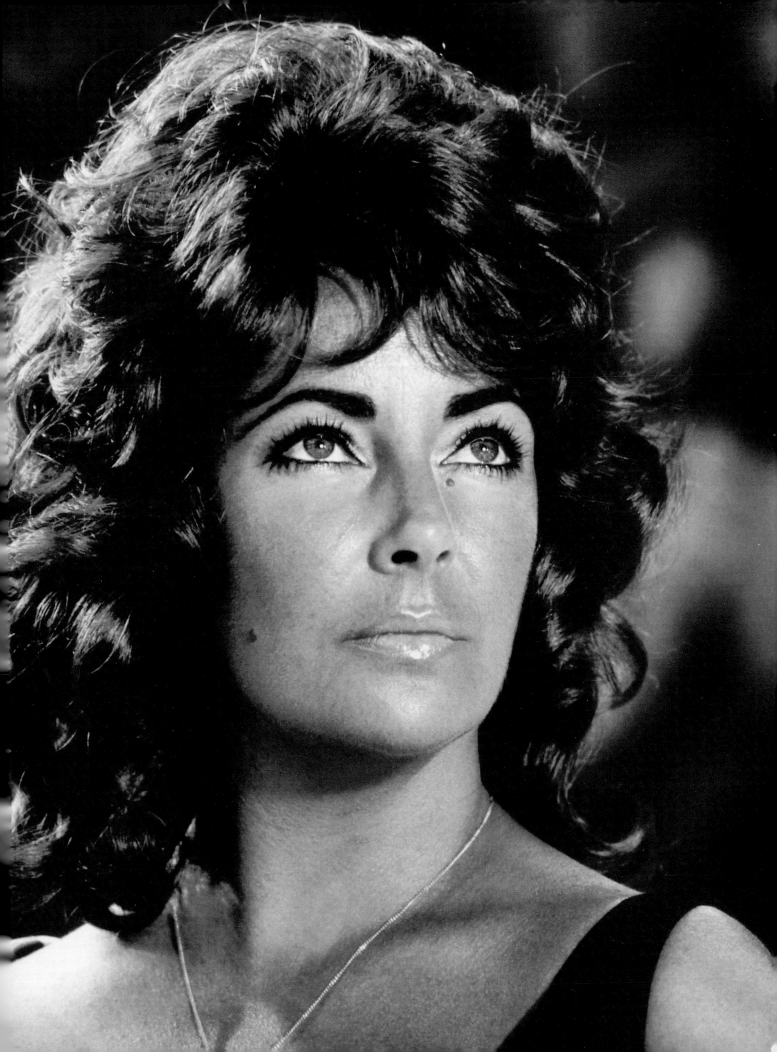

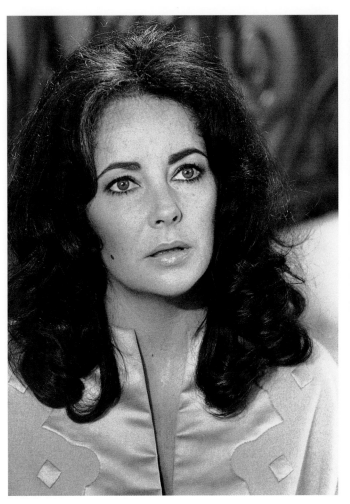
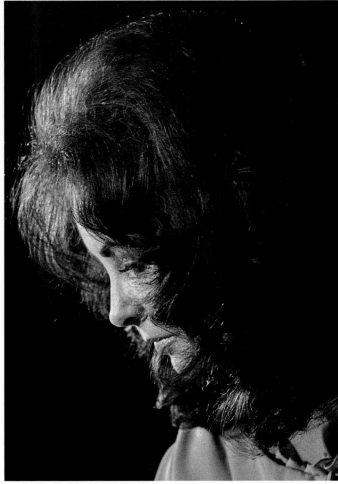

1973. THROUGH THESE FOUR EXPRESSIONS ONE CAN EXPLAIN AND COME
TO UNDERSTAND ELIZABETH: SENSIBILITY, AFFABILITY, SWEETNESS, AND STRENGTH.

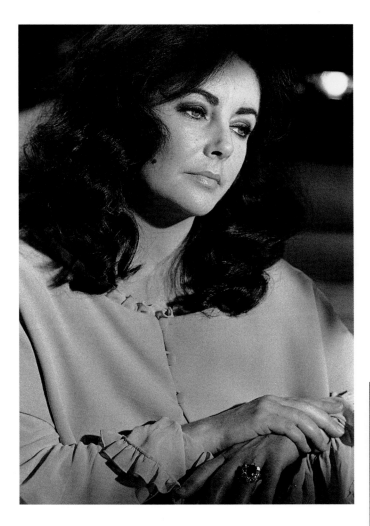

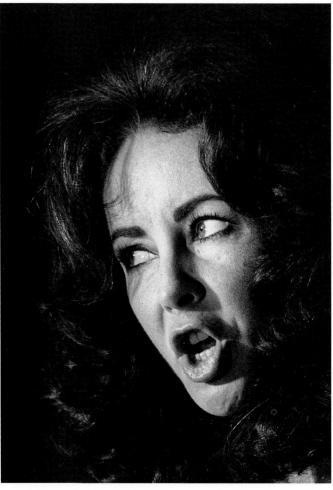

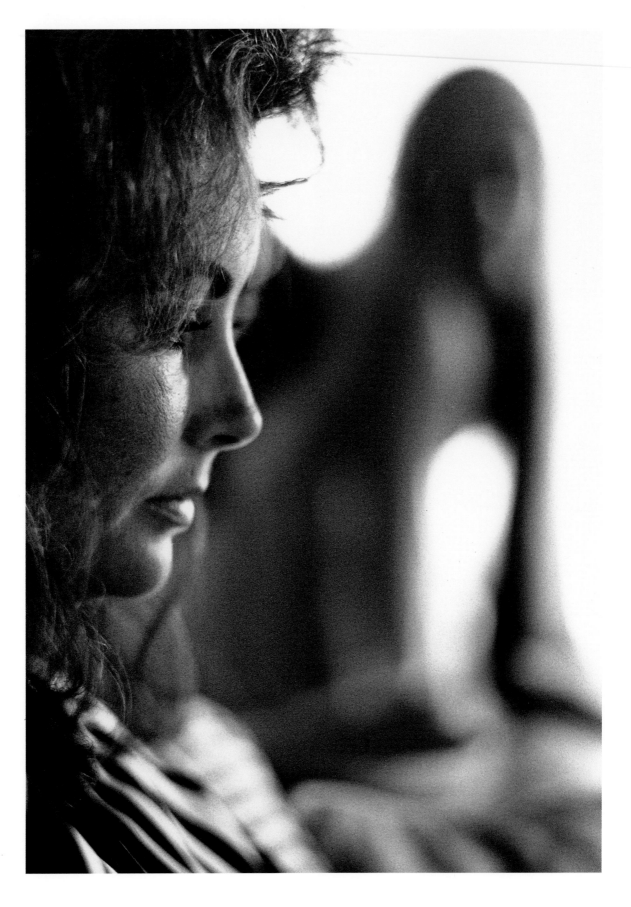

CUERNAVACA, MEXICO. WE WERE TALKING ABOUT GHOSTS, AND I HAD MY LEICA IN MY SHOULDERBAG. *"Click."*

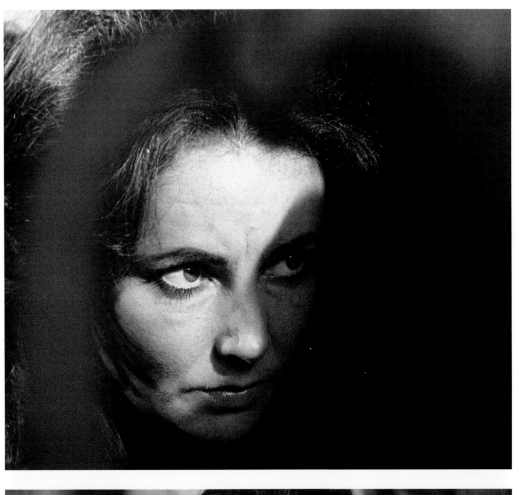

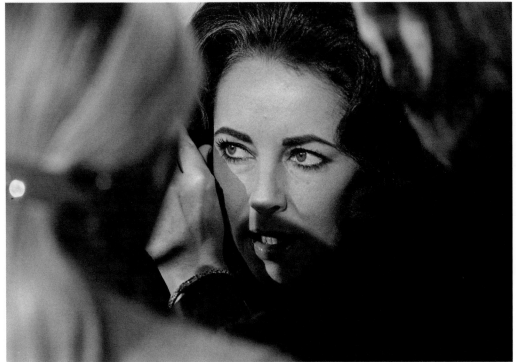

top "I'M READY TO TELL THAT B—— DIRECTOR WHAT I THINK."
bottom "I HOPE HE UNDERSTOOD. YOU CAN NEVER BE SURE."

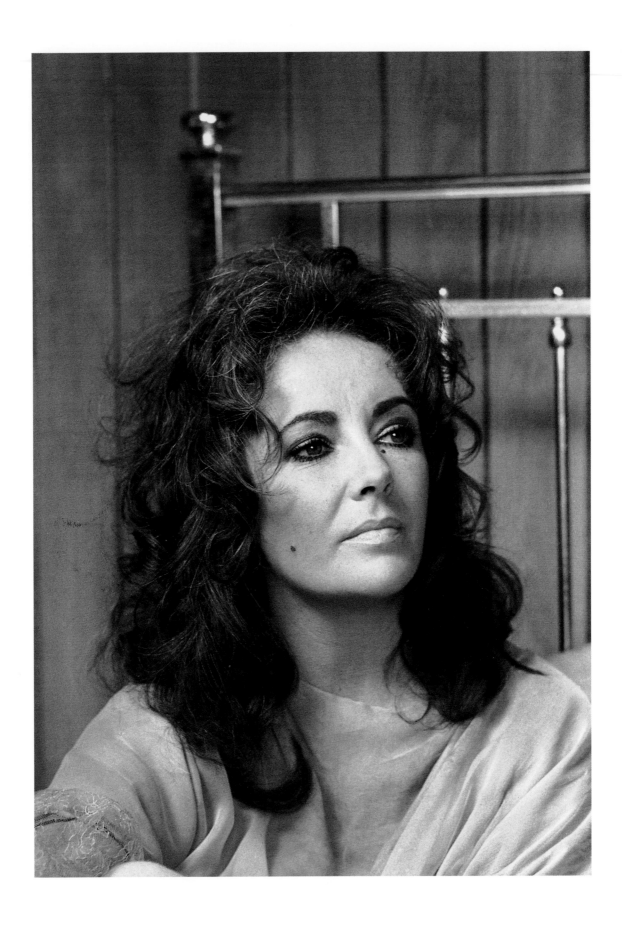

22

DONNA—IN ALL CAPITAL LETTERS.

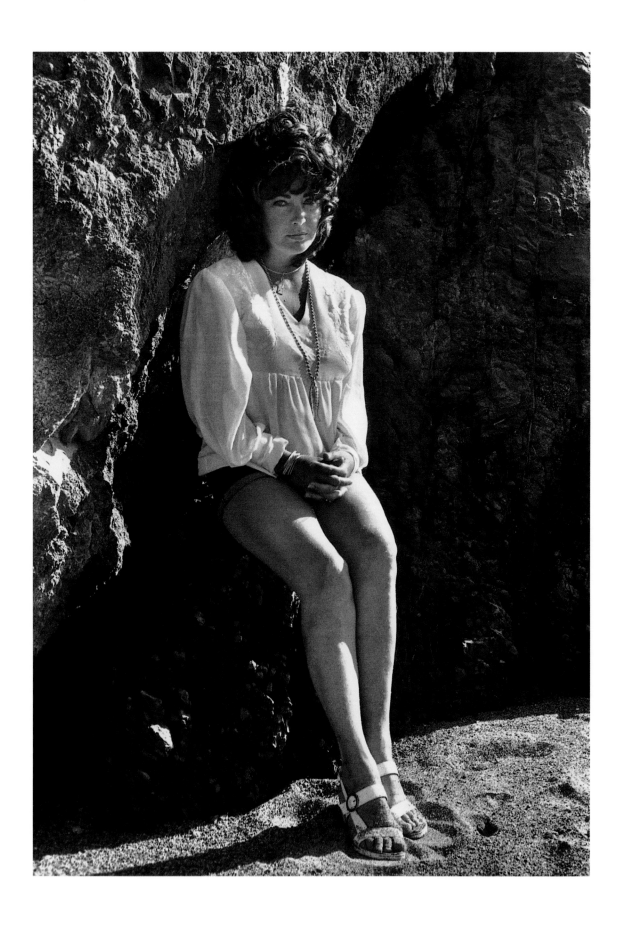

23

Puerto Vallarta, Mexico, 1970. A beautiful thirty-eight-year-old Babe.

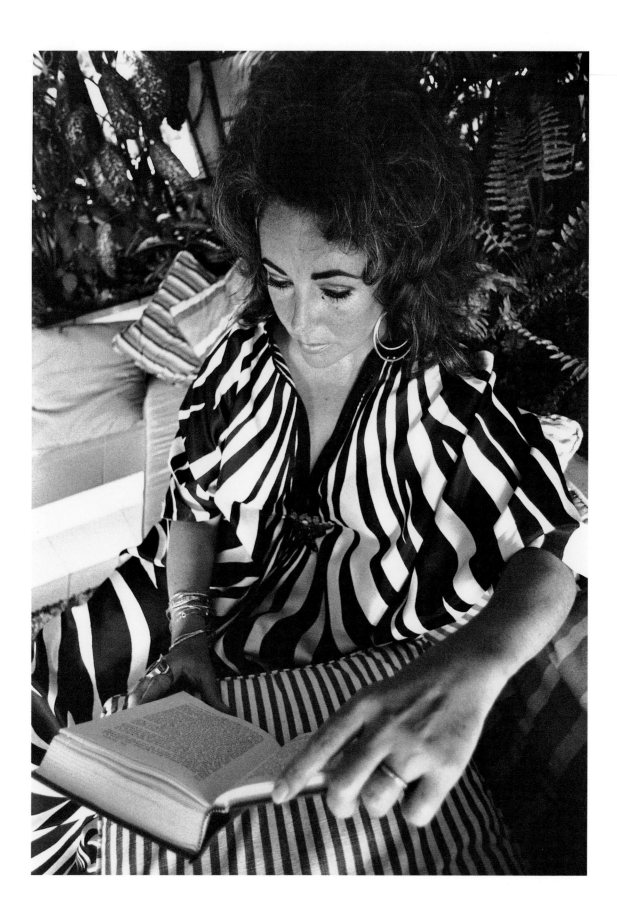

RELAXING MOMENTS, WITH A METAMORPHOSIS CAPTURED FOR POSTERITY.

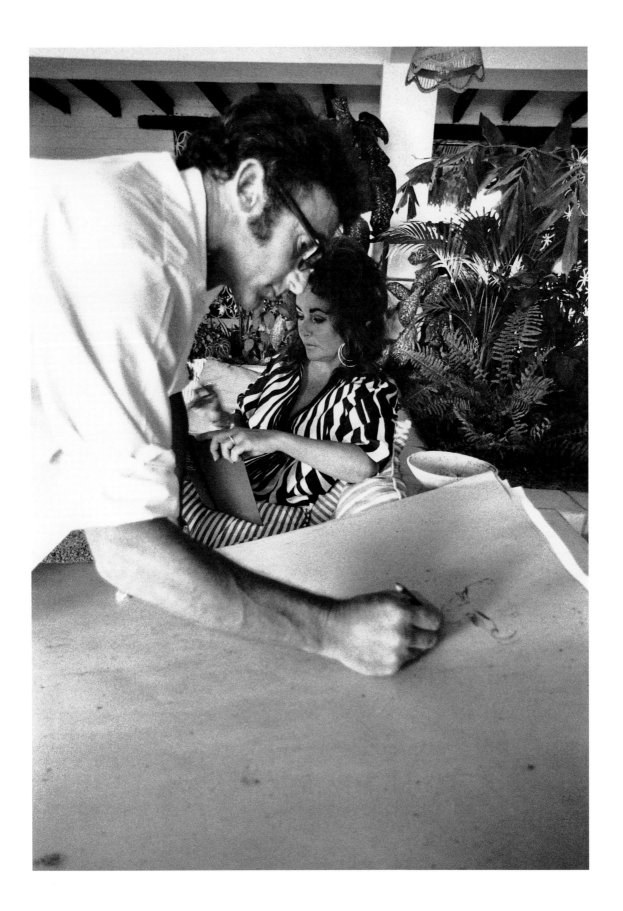

DUBROVNIK, YUGOSLAVIA, 1970. PRESIDENT MARSHAL TITO LOANED ONE OF HIS FABULOUS VILLAS TO RICHARD, WHO WAS WORKING ON THE FILM *The Battle of Sudjesca* INTERPRETING NOTHING LESS THAN THE ROLE OF MARSHAL TITO. I ENDED UP LIVING ALONE WITH A COOK, A BUTLER, AND A MAID. HERE ELIZABETH EMERGES SMILING FROM HER BOAT, THE *Kalizma*, WHICH WAS ANCHORED IN THE NEAR BAY OF KUPARI, WHERE THEY LIVED FOR THE ENTIRE DURATION OF THE FILM. THE NAME KALIZMA WAS COMPOSED OF KA FROM KATE, RICHARD'S SECOND DAUGHTER WITH HIS FIRST WIFE; LIZ FROM LIZA, ELIZABETH'S THIRD BORN WITH MIKE TODD; AND MA FROM MARIA BURTON, ADOPTED DAUGHTER OF THE COUPLE.

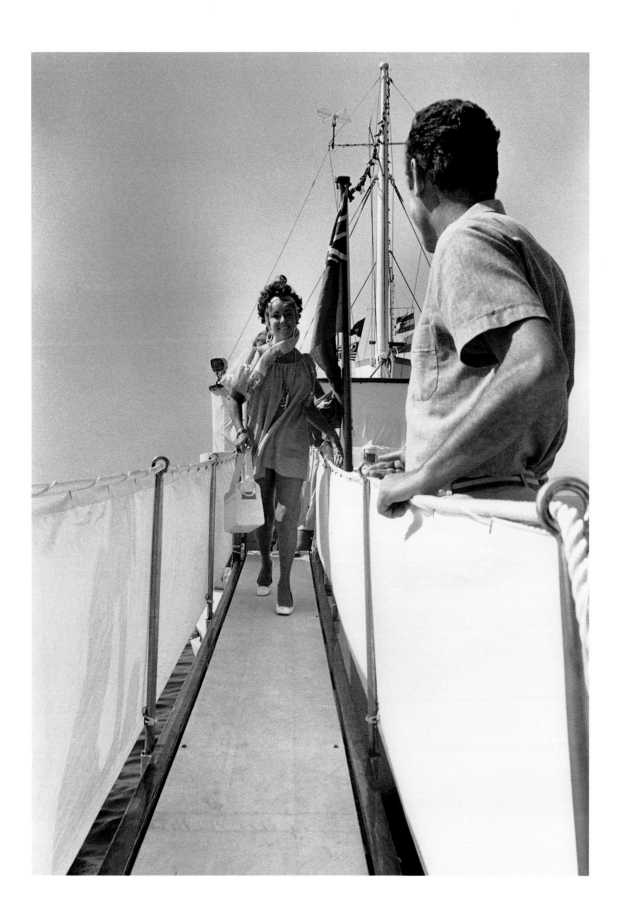

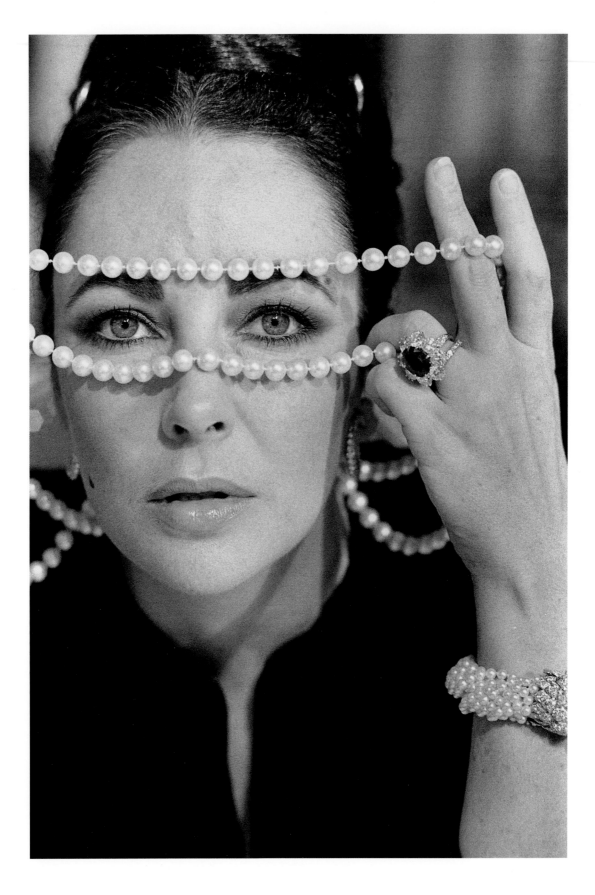

CORTINA D'AMPEZZO, ITALY, 1973. QUEEN ELIZABETH TAYLOR-BURTON—FAMOUS FOR HER JEW-ELS, BUT WHICH ONES? THE ROCKS ON HER FINGERS OR THE JEWEL-LIKE SYMMETRY OF HER FACE? *opposite* SHE HAS EYES THAT SPEAK, THAT REFLECT THE SKY IN A PERIWINKLE SEA.

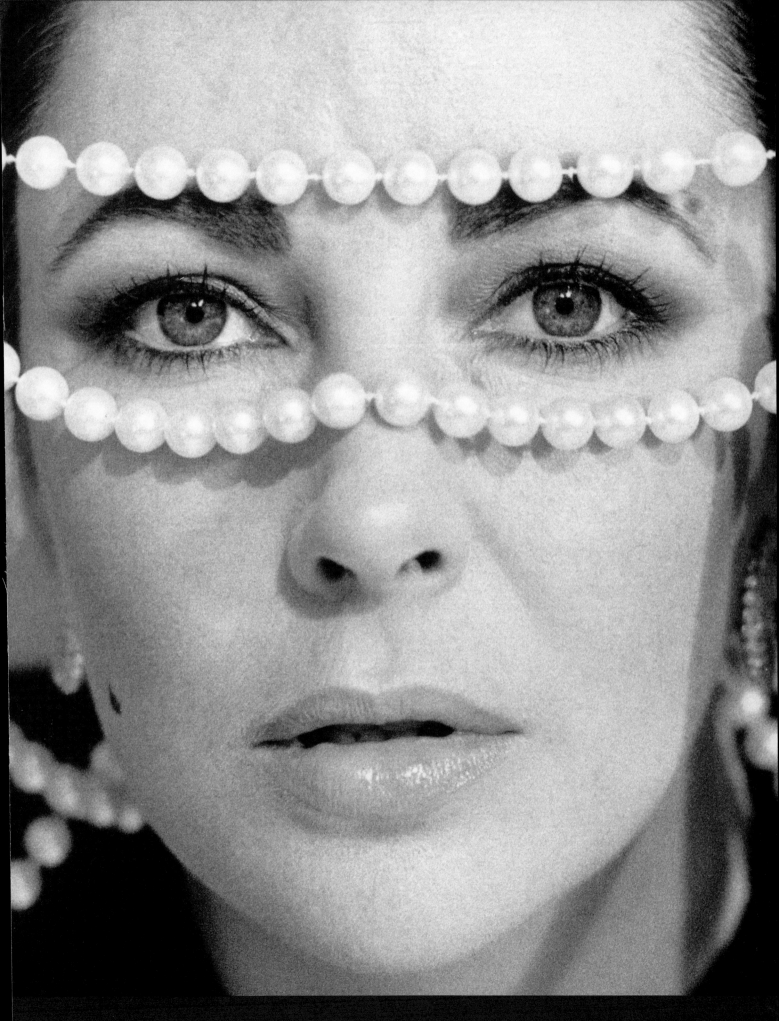

Monte Carlo, 1971. On her neck a sixty-nine-carat diamond: *"My darling Gianni I love you, Elizabeth."* "I love you too!"

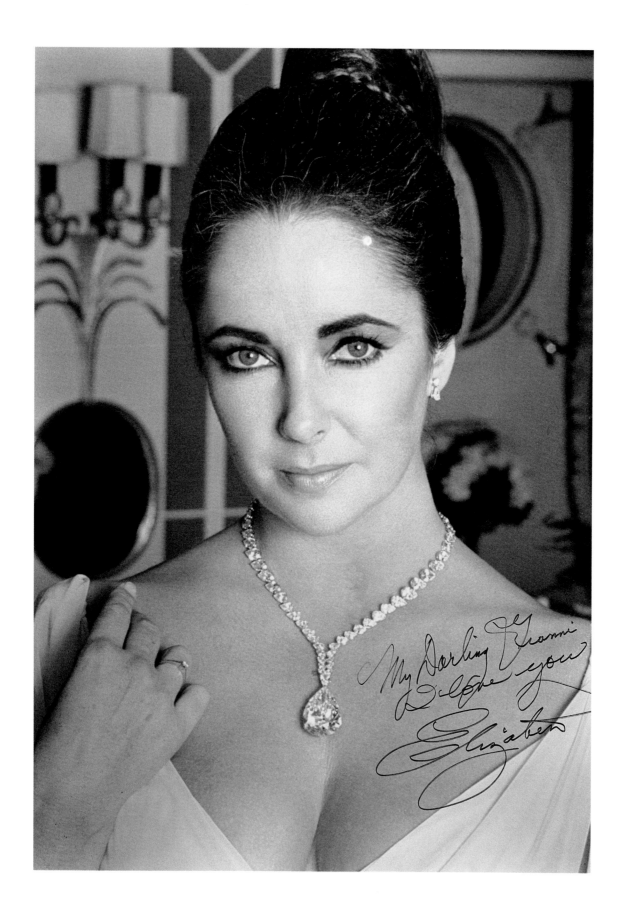

My Darling Gianni I love you
Elizabeth

32

LONDON, 1968. IT'S ONLY 6:30 IN THE MORNING AT THE PINEWOOD STUDIO,
AND SHE'S ALREADY PLAYFUL IN FRONT OF MY CAMERA.

THE VILLAGE OF BUSSERIA, MEXICO, 1968. ELIZABETH WITHOUT ANY MAKEUP, WITH HER CHILDREN MICHAEL, CHRIS, AND LIZA POSING FOR ME, WHICH WAS VERY RARE.

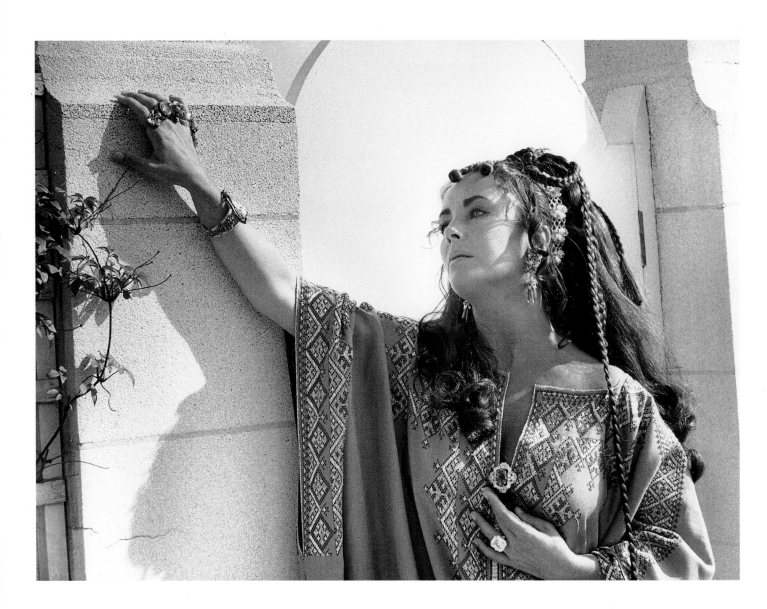

LONDON, 1969. WE'RE ON THE TERRACE OF THE DORCHESTER HOTEL, AND ELIZABETH WEARS
A CAFTAN EMBROIDERED WITH GOLD (TWENTY-FOUR KARAT) AND SILVER THREAD GIVEN TO HER
BY THE EMPRESS OF IRAN, FARAH DIBA. IT WAS ENTRUSTED TO ME IN TEHRAN AND WEIGHED A
TON. THAT LITTLE WHITE SPOT ON HER LEFT HAND IS NONE OTHER THAN "THE CRUP DIAMOND,"
THIRTY-THREE PERFECT CARATS.

opposite SHE GRATEFULLY DEDICATED THIS PHOTOGRAPH AND SENT IT BACK TO FARAH DIBA
THROUGH ME. THE JEWELS SHE IS WEARING ARE PERSIAN.

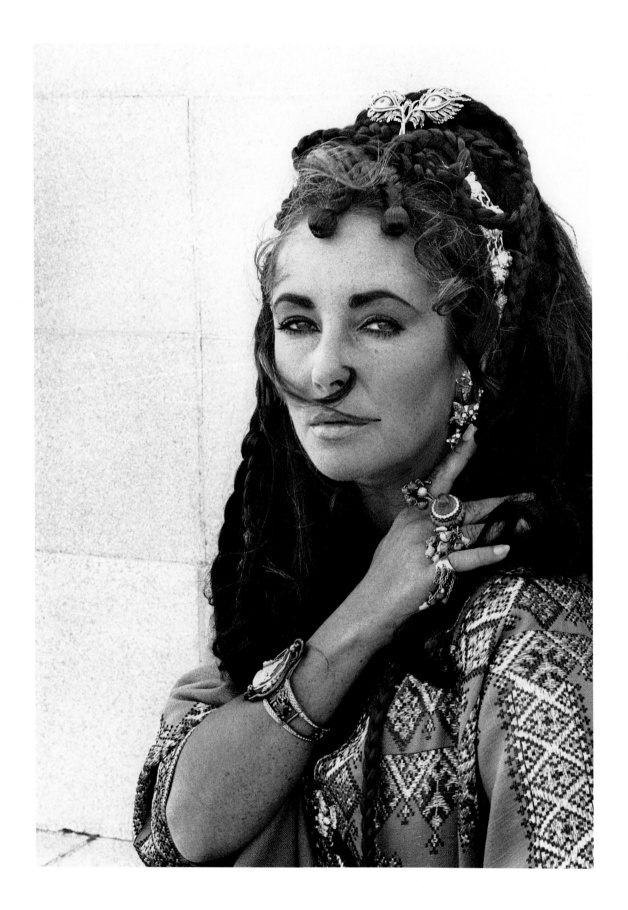

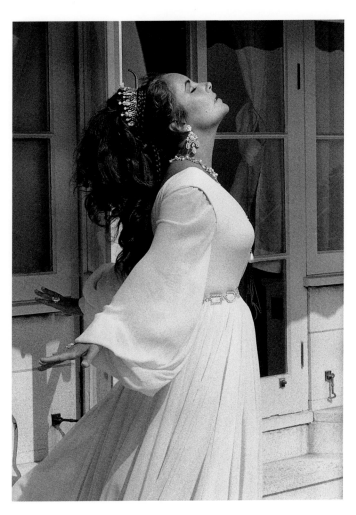

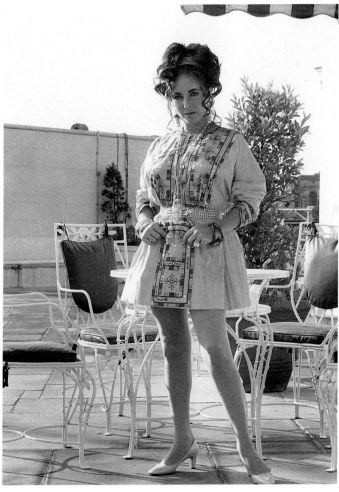

ELIZABETH WANTED TO HAVE FUN THIS DAY. BY THE END OF THE DAY SHE WILL HAVE CHANGED
TWENTY TIMES FOR DIFFERENT PHOTOGRAPHS AND SOMETIMES JUST TO HAVE A LAUGH.

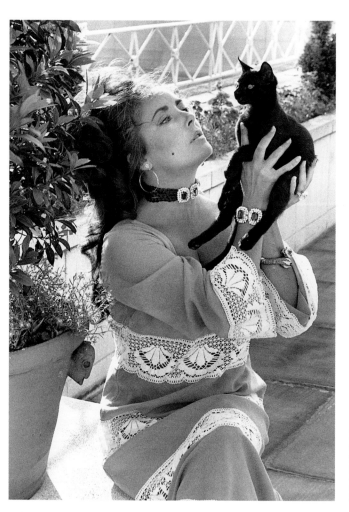 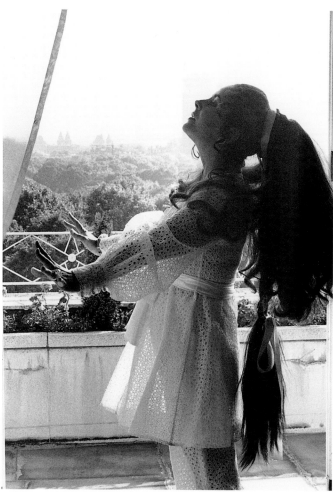

38 London. This ruby necklace and ring were given to Elizabeth by her third husband Mike Todd.

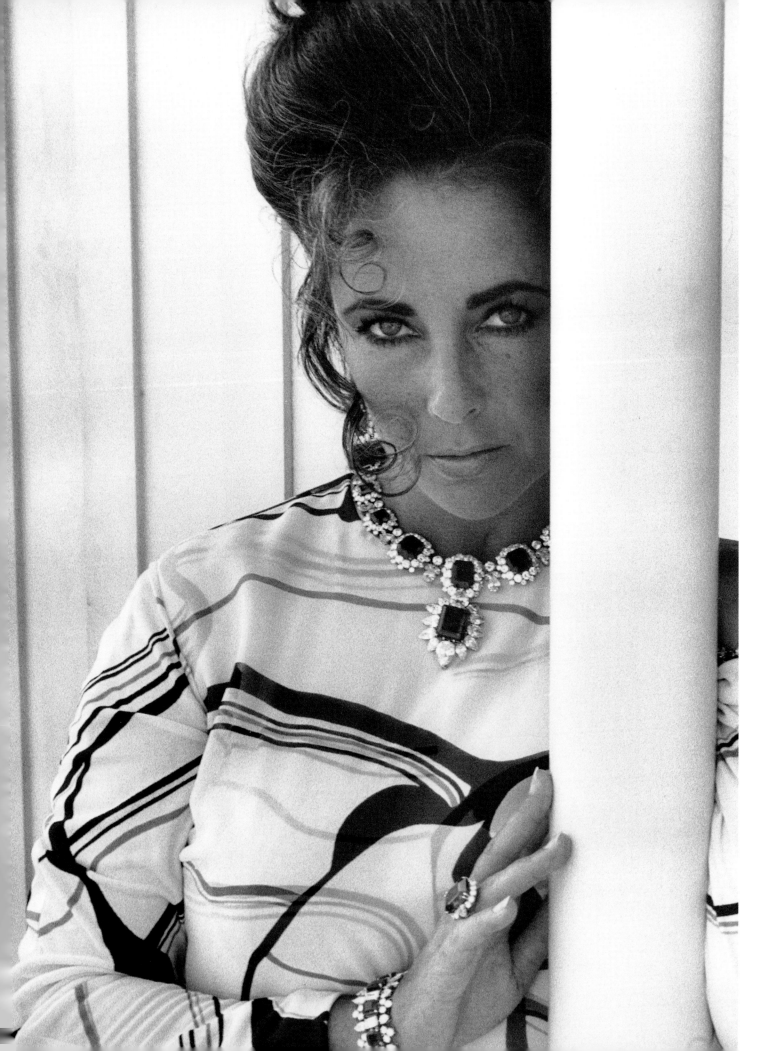

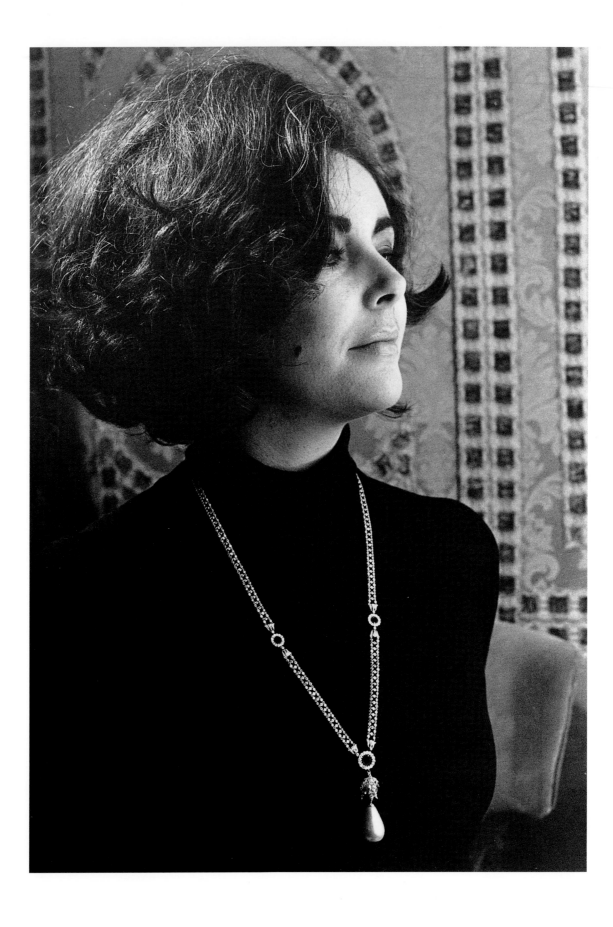

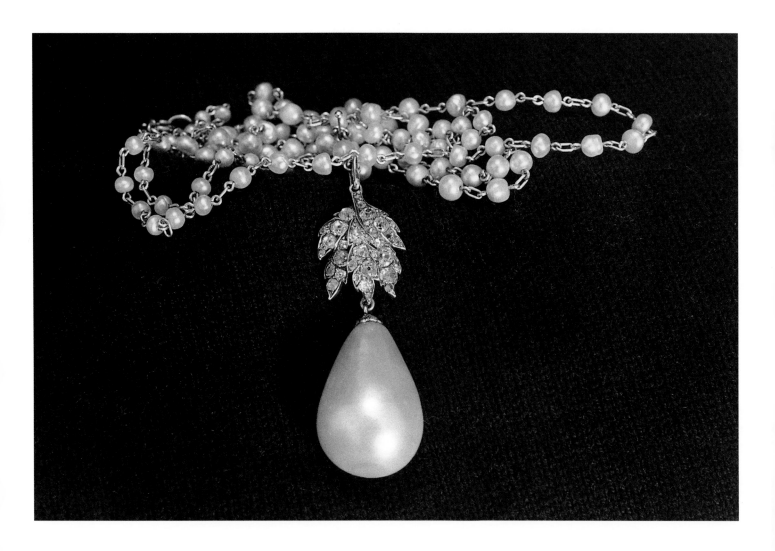

ROME. THE PELLEGRINA PEARL, THE LARGEST IN THE WORLD. LEGEND HAS IT THAT THE PEARL IS
BAD LUCK TO WHOEVER POSSESSES IT. THINGS STARTED TO GO DOWNHILL BETWEEN ELIZABETH
AND RICHARD SOON AFTER THEY PURCHASED IT, BUT I'M NOT INSINUATING ANYTHING.

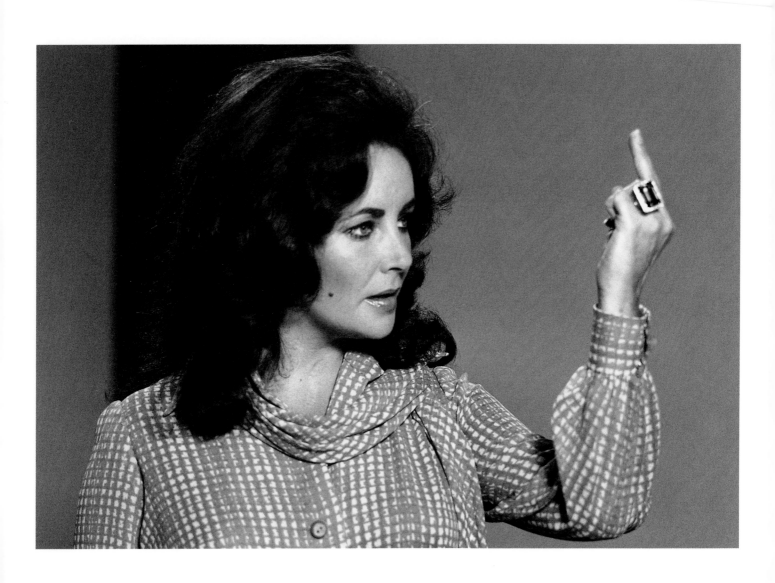

LONDON: SHE'S ONLY SHOWING OFF THE RING!

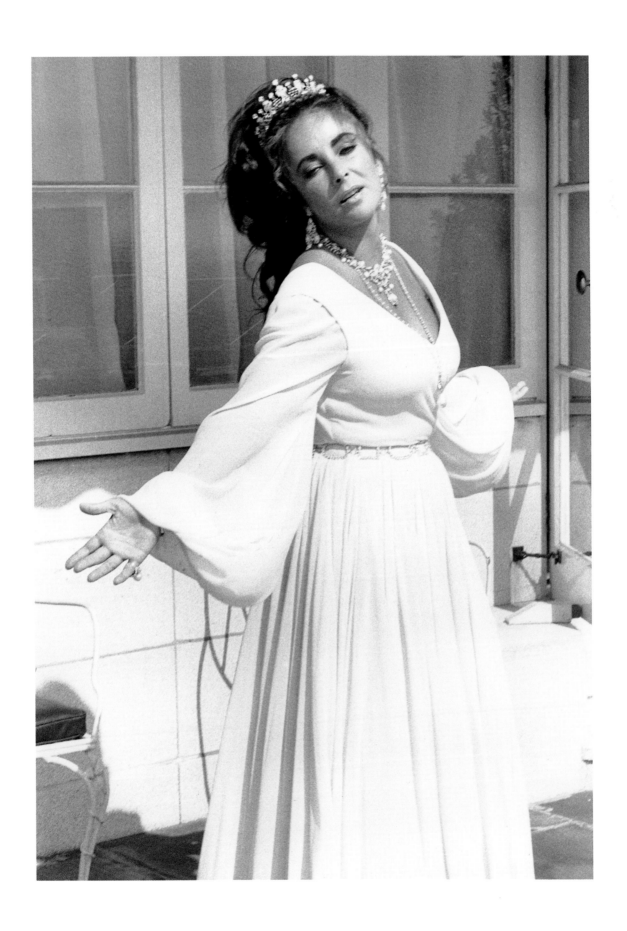

BEJEWELED QUEEN OR LOWLY MAID, SHE'S ALWAYS BEAUTIFUL.

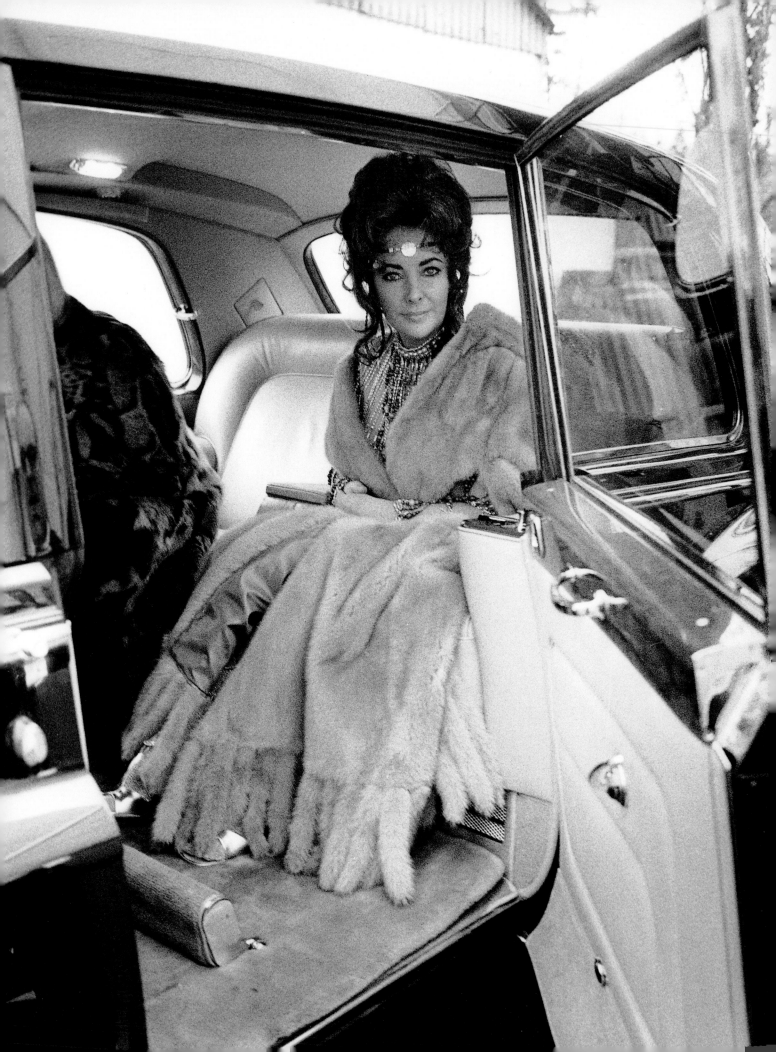

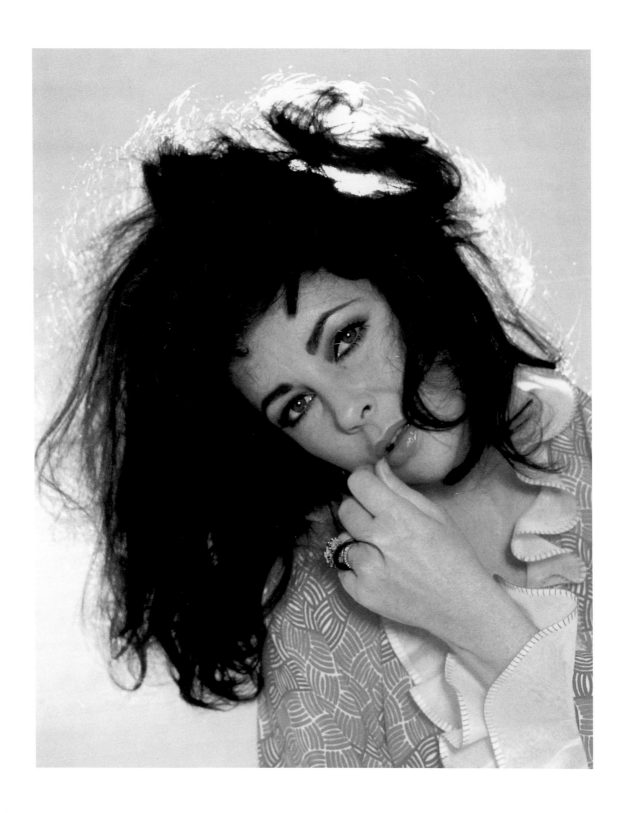

45

THE ONLY TIME I EVER PHOTOGRAPHED HER IN MY STUDIO IN ROME.
opposite THE FIRST DAY OF SHOOTING AND ALL IS CHAOS. ELIZABETH TAYLOR BURTON ARRIVES
IN HER ROLLS ROYCE PHANTOM AND EVERYTHING FREEZES.

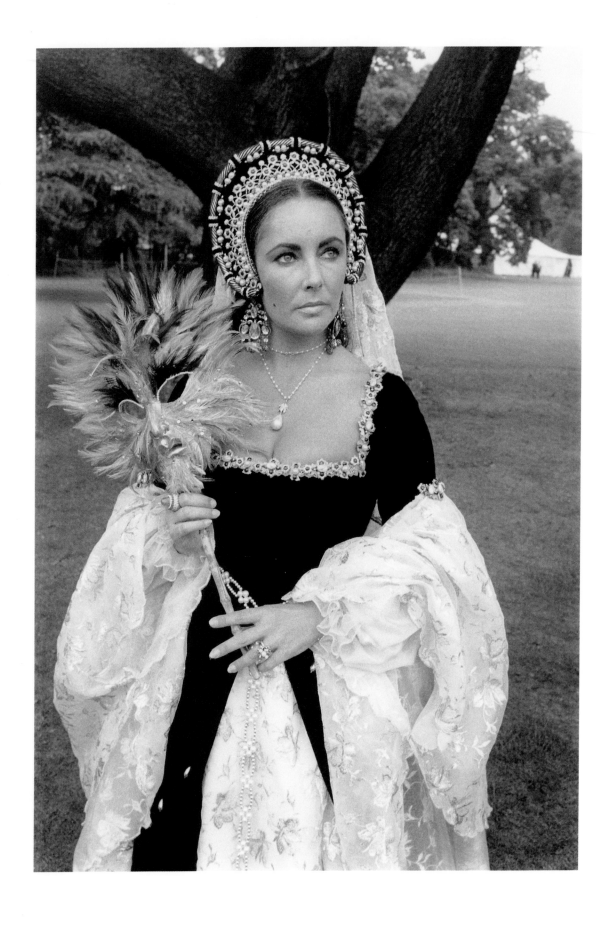

LONDON, 1969. *Anne of the Thousand Days.* RICHARD BURTON PLAYS THE LEAD ROLE, HENRY VIII. ELIZABETH TAYLOR'S ONLY TIME AS AN EXTRA.

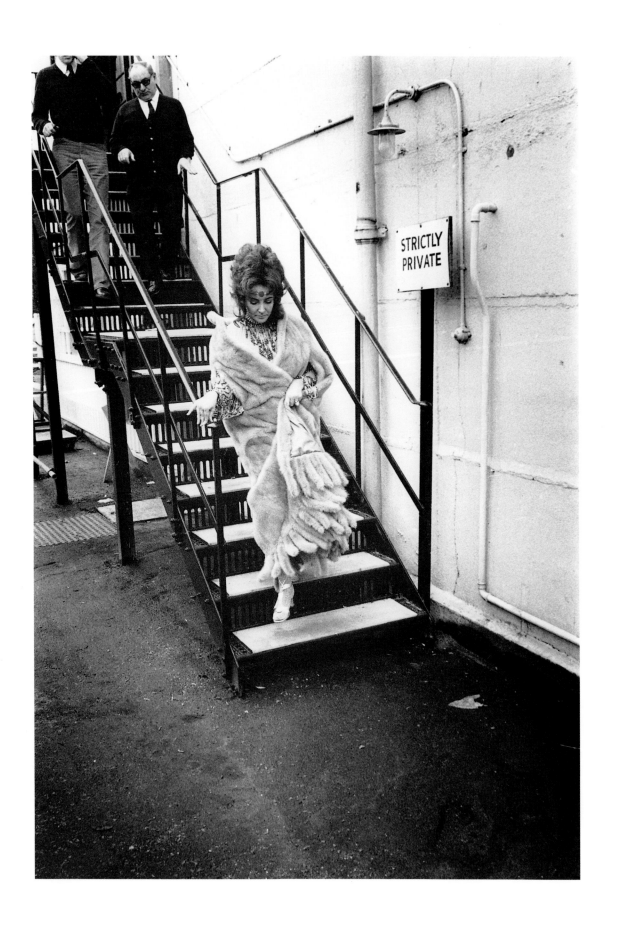

STRICTLY
PRIVATE

47

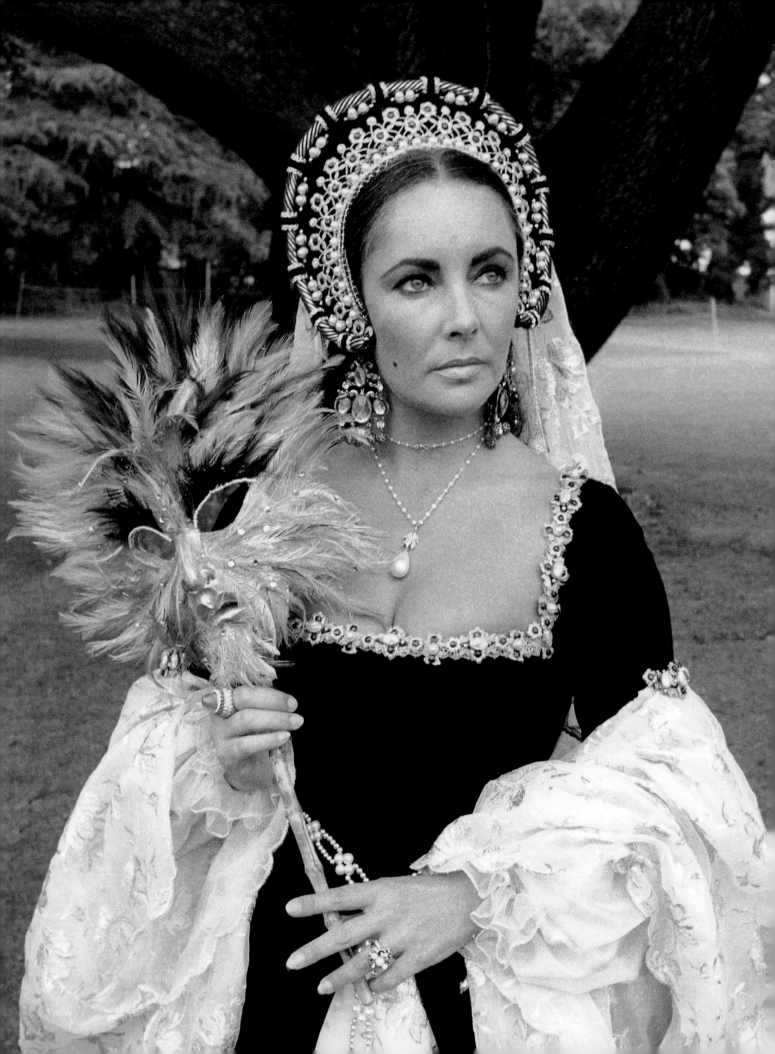

Part 2

FILMS

With Elizabeth and Richard, I often felt ill-at-ease, like a guest in a foreign place. They were cultured and sophisticated and unlike any people I had known. I was a dropout from the streets of Rome. Because my English was very limited, I became all the more introverted. Ironically, my discomfort and quiet nature added to the aura of glamour and mystery I projected at their side and became another component of my success.

My understanding with Elizabeth was that I could take any photograph of her that I wished and sell it anywhere that I wished, as long as she approved of the image. This already was my philosophy—the opposite of a paparazzi's. I took photographs for three reasons: to please the audience, to please the subject, and to please myself. If Elizabeth wasn't pleased, it failed one of the three criteria. I never deviated. Every photo that you see of Elizabeth with my credit is an image that she has accepted.

My relationship with her, after that false start, was instantly and forever very warm. Our relationship became a friendship and a trust. I was privileged to experience the trust of the most famous actress in the world—a woman whose fame, in the 1960s, was of a unique magnitude—and I felt the responsibility of curating her image.

I rarely asked Elizabeth to pose. I wanted to "steal the moment." That was my specialty. Natural lighting. Almost snapshot circumstances, but with superior equipment and imaginative film stock. And I was always there, waiting. Gradually, little by little, she began to pose, edging toward better light, moving slightly to offer a vantage. She sensed I was ready. She could hear the click. This rapport was based not on talking, not on a nod or look, but on the trust between us.

That trust led to so many adventures. We virtually lived together for eight years, from 1966 to 1974, spending long amounts of time in London, Paris, Los Angeles, New York, Puerto Vallarta, and Gstaad; living in villas and on their yacht; traveling by limousine, private plane, and helicopter.

After our initial misunderstanding I realized that Elizabeth liked me, and that she grew to love me as I did her, but I was not sure about Richard. After all, I was there to photograph his wife, not him. He hated it when someone made the mistake of calling him "Mr. Taylor." And he was supremely proud but also profoundly jealous of any man's attention to his wife.

But, in time, I learned to know Richard, and I think he grew to accept me as his friend. I admired him for many reasons, not the least for his devotion to Elizabeth, which was fierce despite the hard times they went through together. In 1966 I was with him when he visited Oxford for an honorary degree, and I saw a different side of him. He spoke for two hours—and he was an extraordinary speaker with a very sophisticated way of expressing himself. I froze inside, thinking that I could never dare talk to such a man, one

who would certainly guess that my introverted pose concealed a dummy. After the speech, Richard told Elizabeth to take Claudye back to the hotel. "Gianni and I are going to hit the pub." I didn't know we were going to hit every pub in Oxford! That was my first encounter with beer. "My gosh, how much I pee," I remember muttering over and over. That night, however, we talked—and many times after that.

Richard never treated me as I had feared. The public knew Richard as a formidable actor and the husband of Elizabeth Taylor, but his qualities as a human being were under-appreciated. In 1968, when Claudye and I decided to get married, Richard and Elizabeth were the natural choices as best man and matron of honor.

I remember my father coming to London for the first and only time in his life, riding in a Rolls Royce placed at his disposal by film producer Elliot Kastner, and being taken by me to meet Elizabeth. He was terribly anxious over the trip but also over meeting this world-famous movie star. She was getting made up in her dressing room on the set of *Secret Ceremony*. When I told her my father had arrived, she ran out and hugged him, giving him a big kiss on the mouth. He was so taken aback, he almost fainted. He was entranced for twenty minutes afterwards. "Don't tell your mother she kissed me on the mouth," he kept saying.

For my father, meeting Elizabeth validated my job. He was never sure that I was doing the right thing with "his talent." He would take a look at my photos and say, "You're getting there . . ." One of the last times we talked about my work, I remember him saying, "You're not there yet . . ." That challenge was always important to me.

Claudye and I said our vows, with Elizabeth and Richard standing up for us, at the country house of Alexandre de Paris, the man who fashioned hair for the queen of England, Farah Diba Pahlavi (the wife of the shah of Iran), and Grace Kelly, as well as for Elizabeth. On that day, I recall, there were at least a hundred photographers swarming outside

the estate trying to get pictures of all the celebrities. That too belongs to the memory of those chaotic times, the press and paparazzi chasing us wherever we went.

When Elizabeth and Richard separated the first time, in July 1973, it was difficult for me to take one side against the other. I was also thinking about separating from Claudye. I already had carved my reputation and made my first fortune, and I was thinking of changing careers and moving into film directing and producing.

LAS VEGAS, 1970. IN THE FILM *The Only Game in Town*, ELIZABETH WORKS WITH GEORGE STEVENS, WHO ADORED HER. HE ALSO DIRECTED HER IN *A Place in the Sun* AND *Giant*.

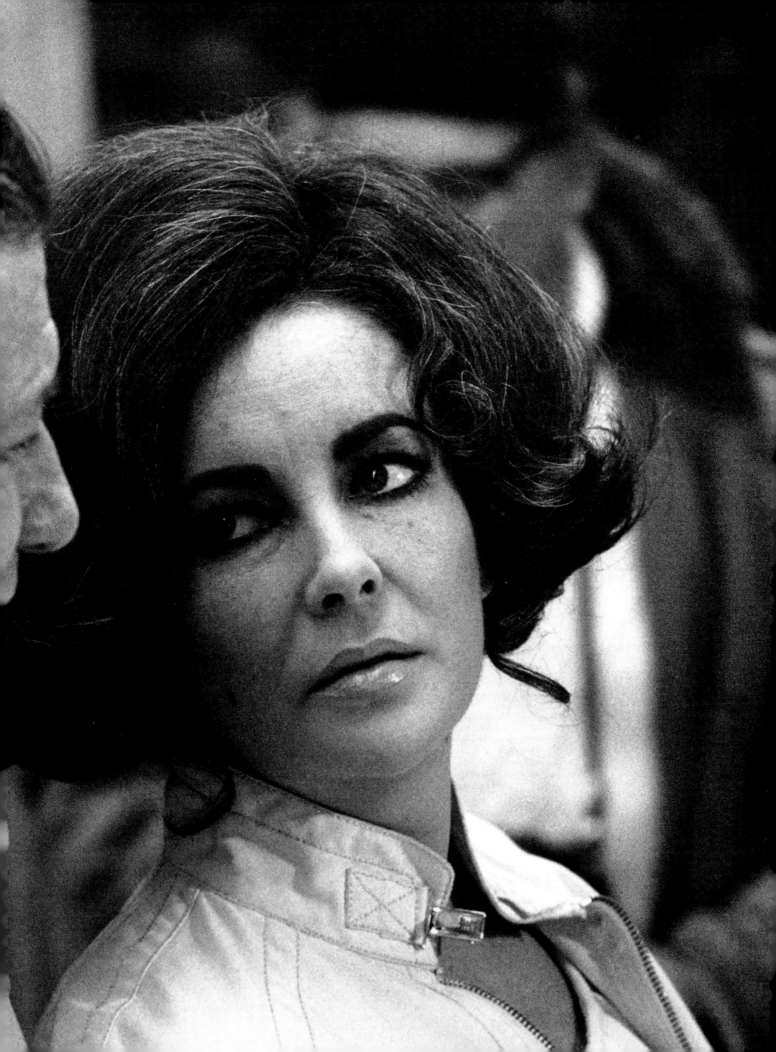

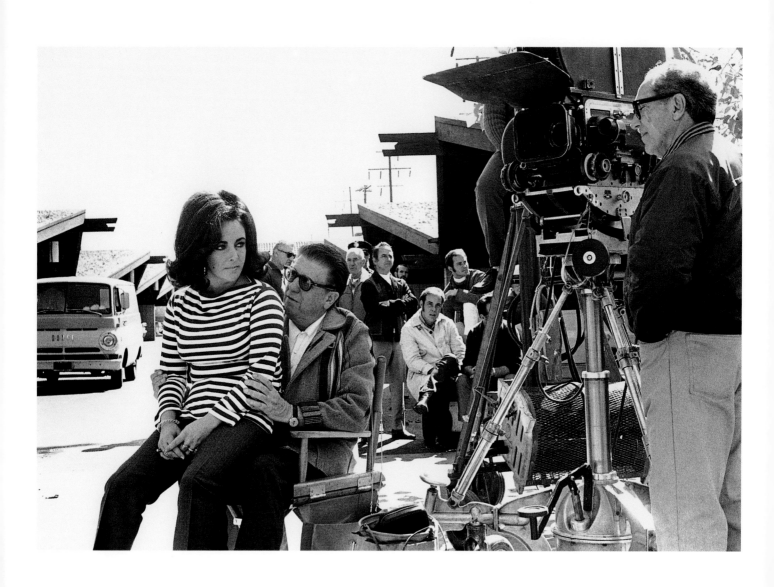

LAS VEGAS. ELIZABETH SITS ON GEORGE'S KNEE TO COMPLAIN ABOUT THE LIGHTING.

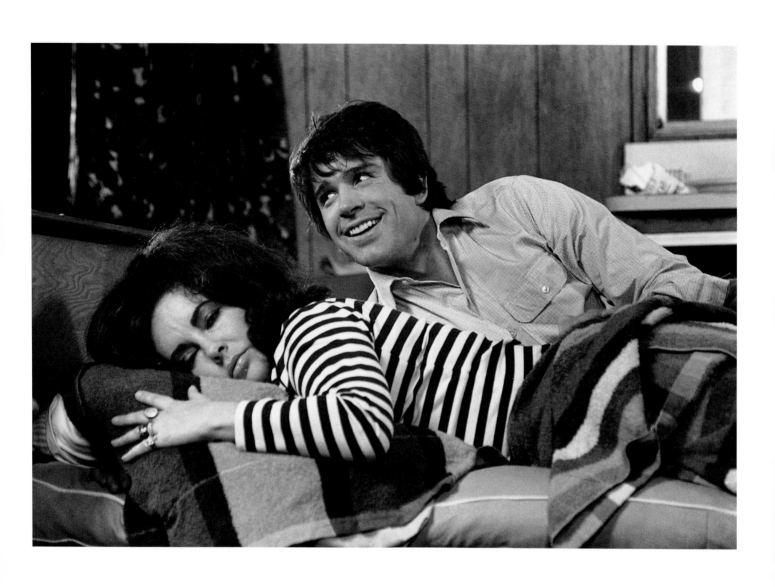

PARIS, 1970. WHEN ELIZABETH AGREED TO DO THE FILM, HER CO-STAR WAS TO BE FRANK SINATRA. HERE SHE'S IN BED WITH HIS SUBSTITUTE, WARREN BEATTY. NO PROBLEM—HA!

58

London, 1972. This photograph appeared in more than three thousand publications in one week—Elizabeth wanted to throw this photograph away, but Richard dedicated a poem to it, or maybe the poem was for Elizabeth. Either way, I was the provocateur. What beautiful memories . . .

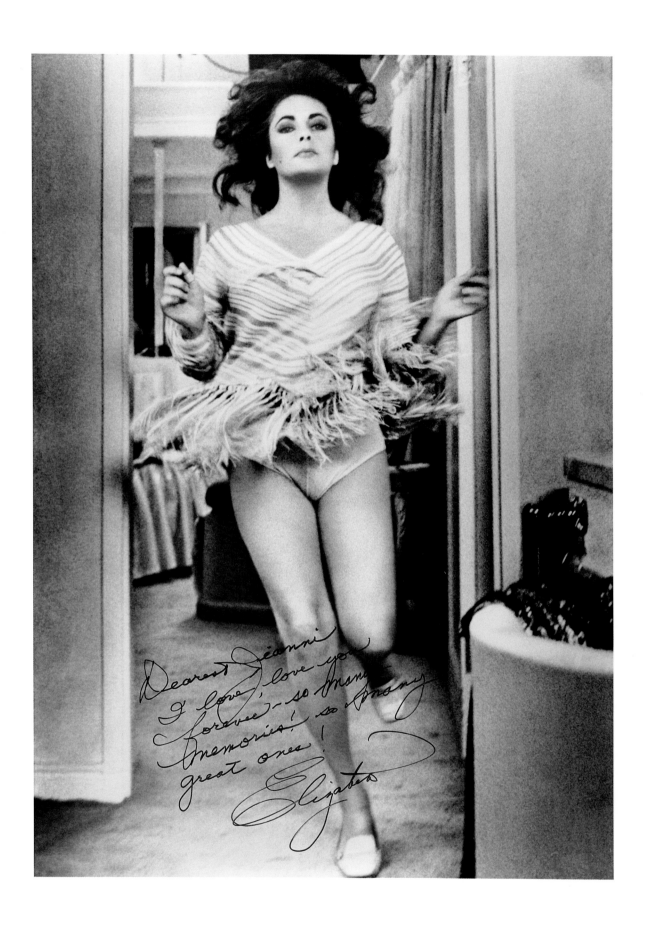

Dearest Jeanni
I love, love you
forever — so many
memories! so many
great ones!
Elizabeth

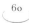

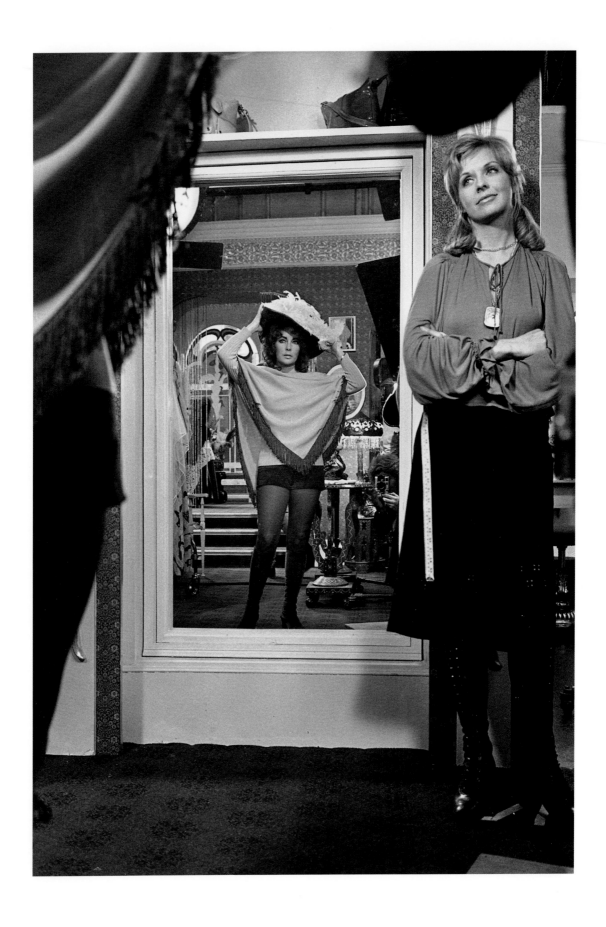

LONDON. THE MIRROR OF TRUTH! APPROPRIATELY, I AM USING THE CAMERA,
A LEICA M2, THAT ELIZABETH GAVE ME FOR CHRISTMAS IN 1966.

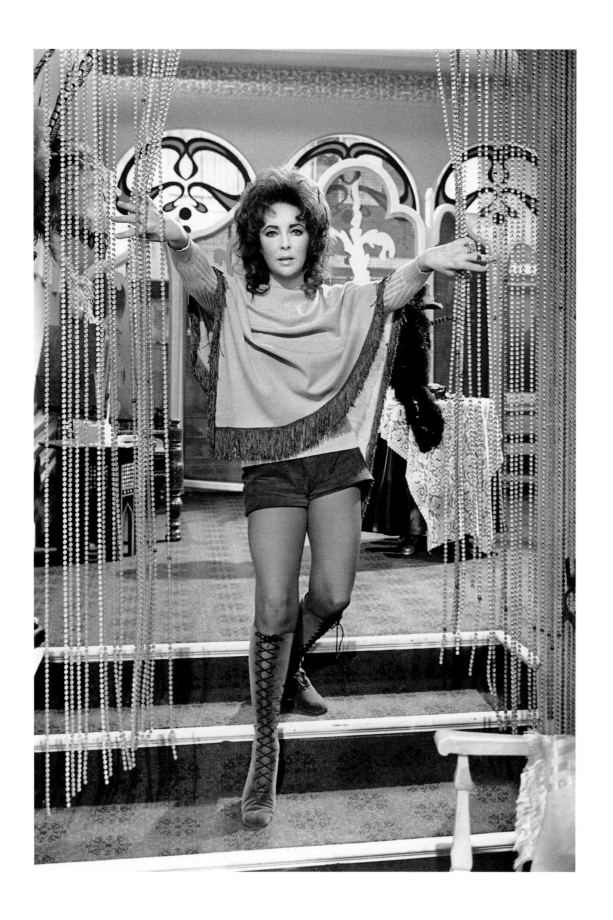

LONDON, 1972. SOME SHOTS CUT FROM THE FILM *XY & Zee* WITHOUT REASON;
A STUDIO EXECUTIVE DECIDED TO CUT SOME SCENES.

 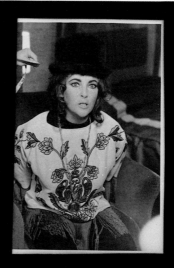 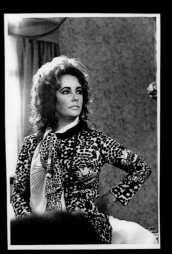

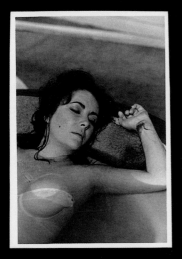 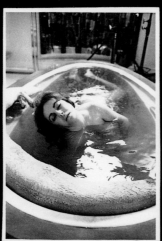 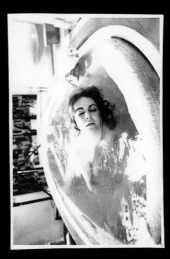 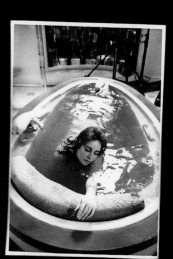

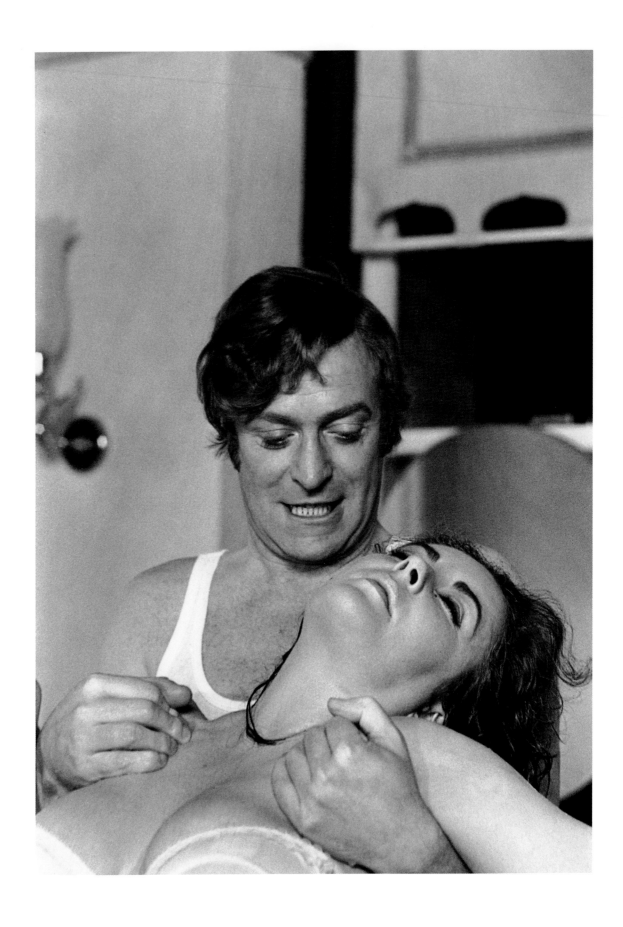

IN A SCENE WITH MICHAEL CAINE. I THINK HE WANTED TO LET HIS HAND SLIP DOWN—
ISN'T THAT WHAT HIS EXPRESSION SAYS?

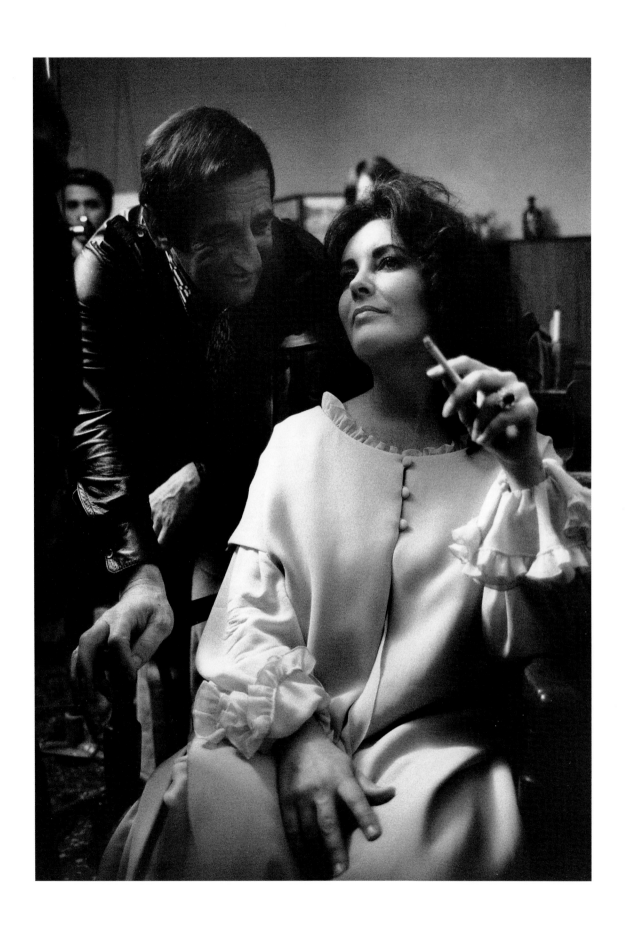

George Barry, the owner of Fabergé: "If you give me a kiss, I'll finance your next film, *Night Watch.*" She did and he did.

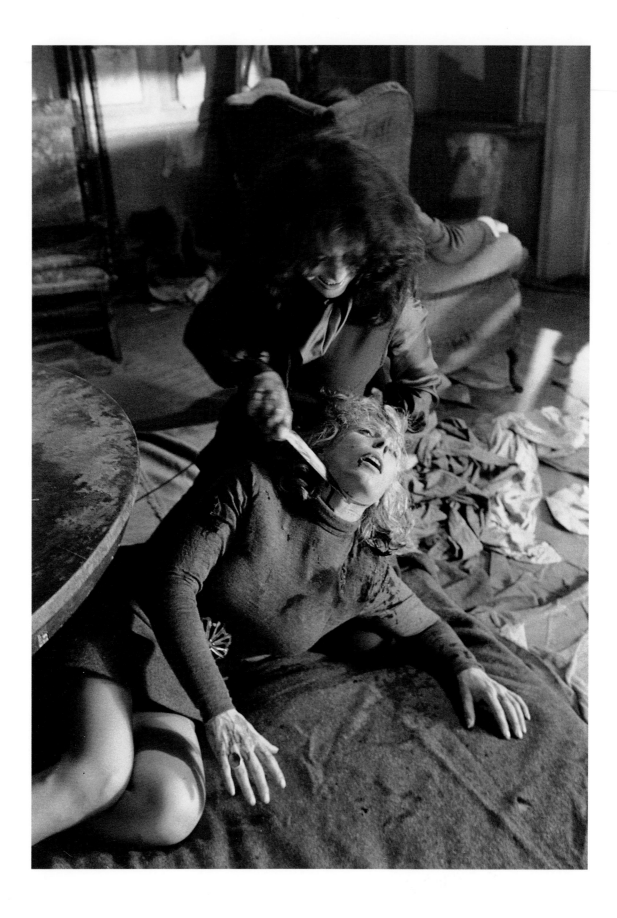

1973. ELIZABETH WAS SO DISTURBED BY THIS GRAPHIC SCENE THAT, "ON HER COMMAND," THE SCENE WAS REMOVED FROM *Night Watch*.

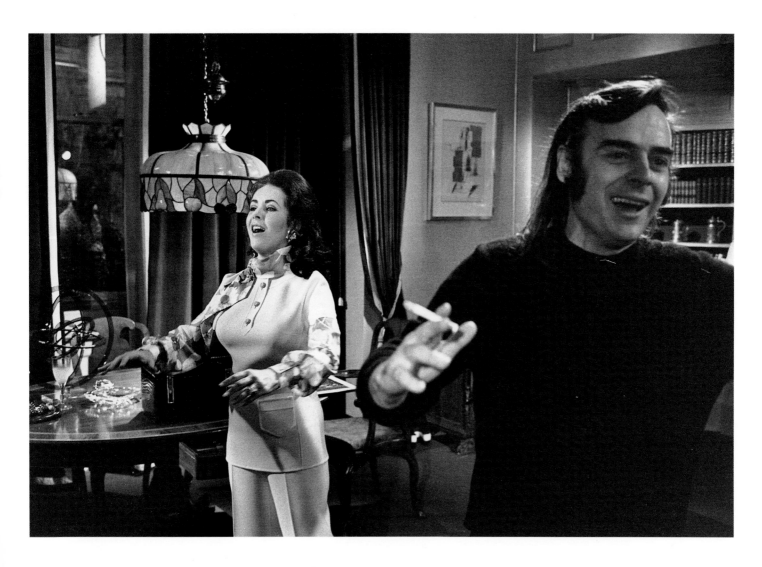

FOR THE LAST FRAME OF *Night Watch* ELIZABETH ASKED DIRECTOR BRIAN HUTTON
TO LET HER BE THE ONE TO SAY "CUT AND PRINT!" INSTEAD SHE SANG, IN
CHORUS WITH THE CAST AND CREW, "FOR HE'S A JOLLY GOOD FELLOW, WHICH
NOBODY CAN DENY!" DEDICATING THE SONG TO BRIAN.

Munich, Germany, 1973. Bigger than life both in films and in private, Elizabeth relaxes against a little window. *Divorce His / Divorce Hers*. A television film showing both points of view in a divorce. I do not recall one person who ever told me they have seen this film.

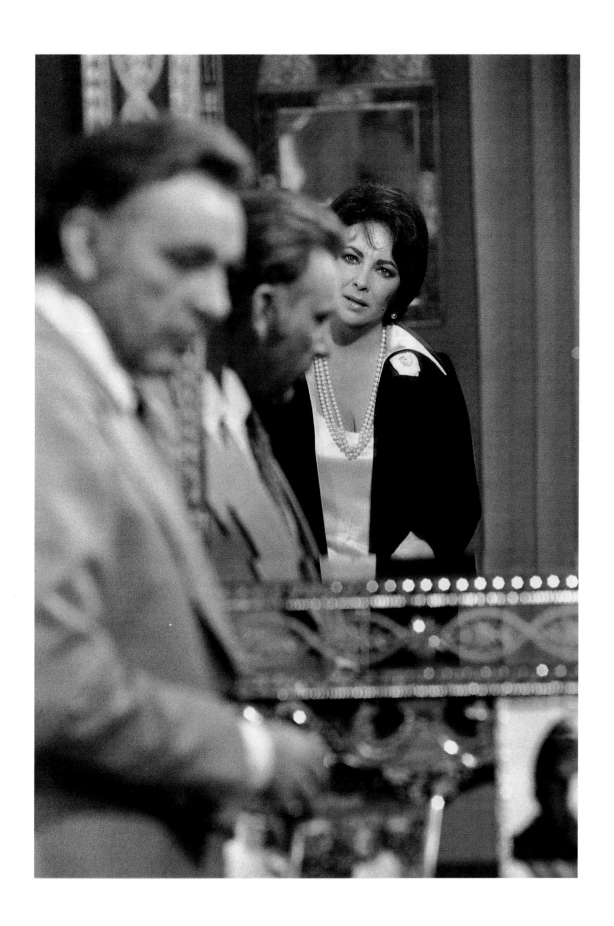

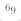
69

MUNICH, GERMANY. THE FIGHT IN THIS SCENE FROM *Divorce His /Divorce Hers* WAS A HARBINGER.

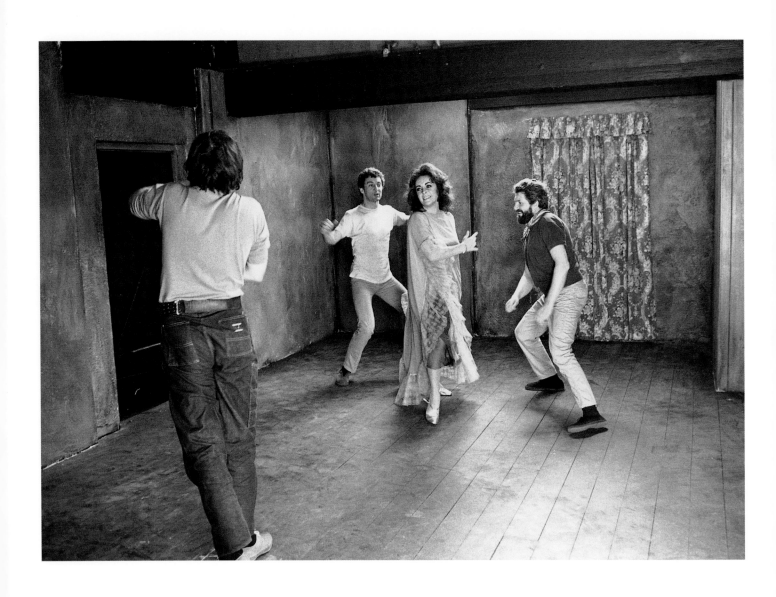

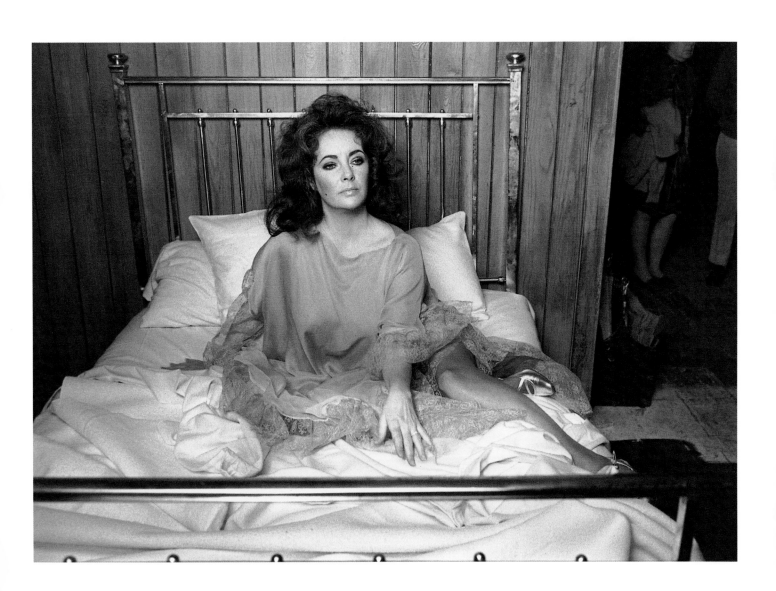

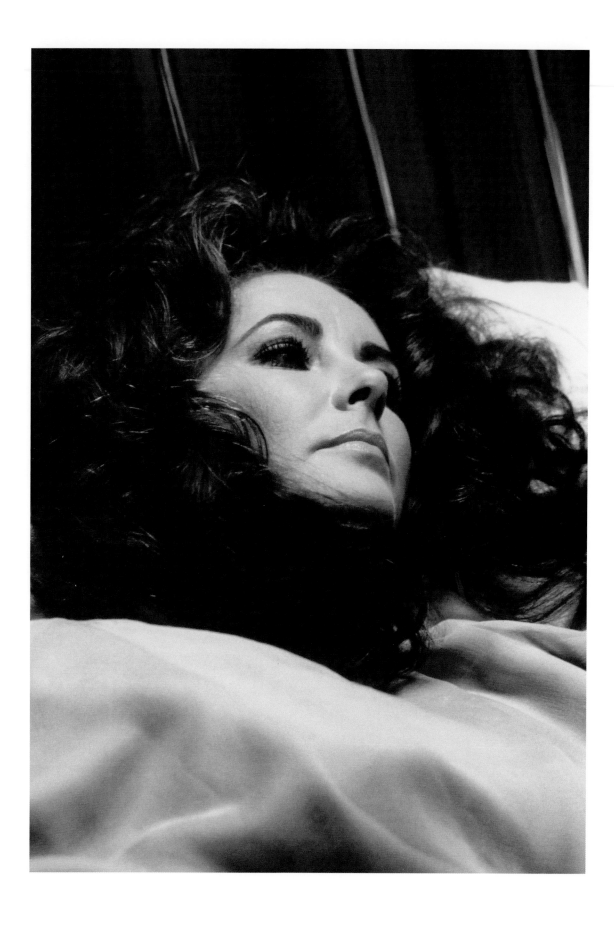

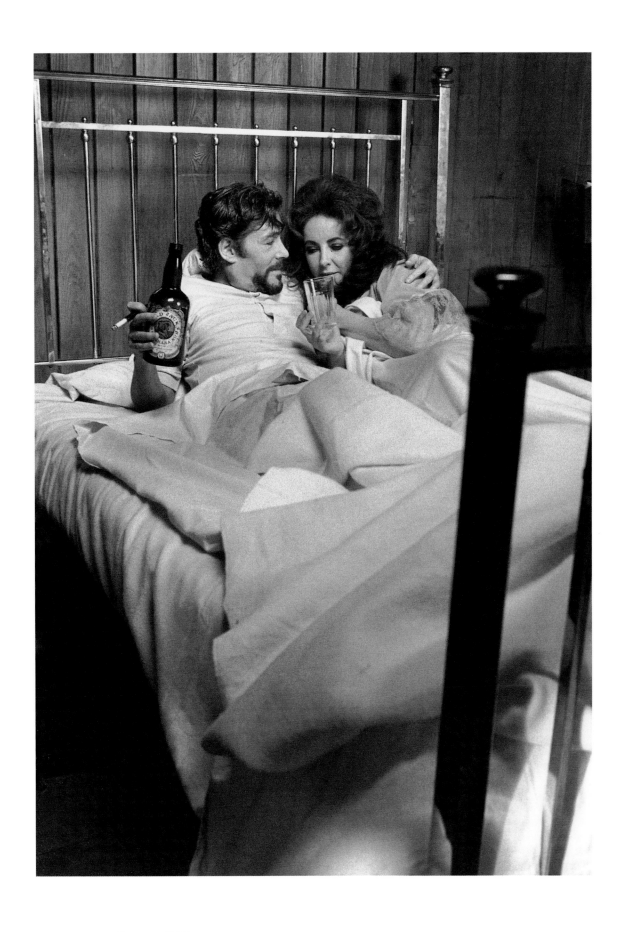

73

PETER O'TOOLE IS HALF DRUNK, BUT OF COURSE ONLY BECAUSE IT WAS CALLED FOR
IN THE SCENE. AND A LITTLE TOO HAPPY TO FIND ELIZABETH IN HIS ARMS.

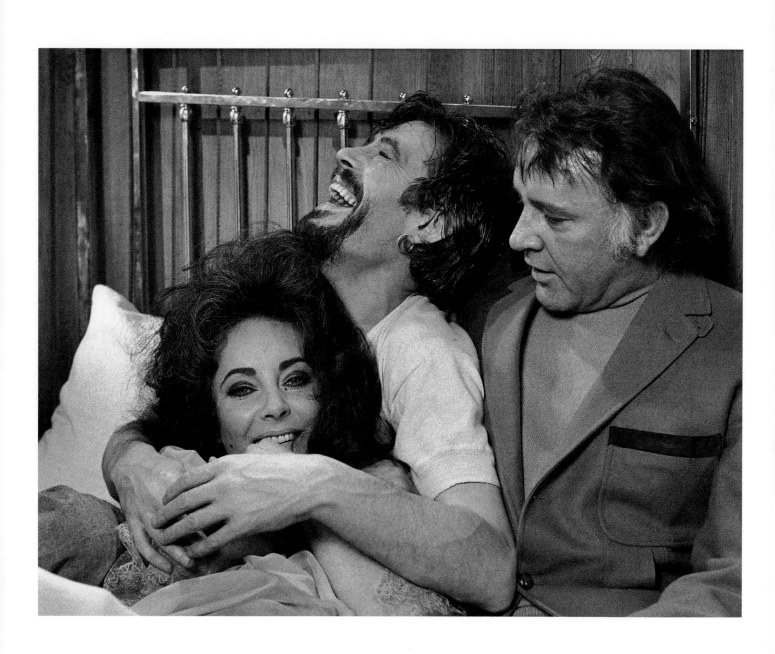

Then Richard arrives: So jealous he's seeing multiple.

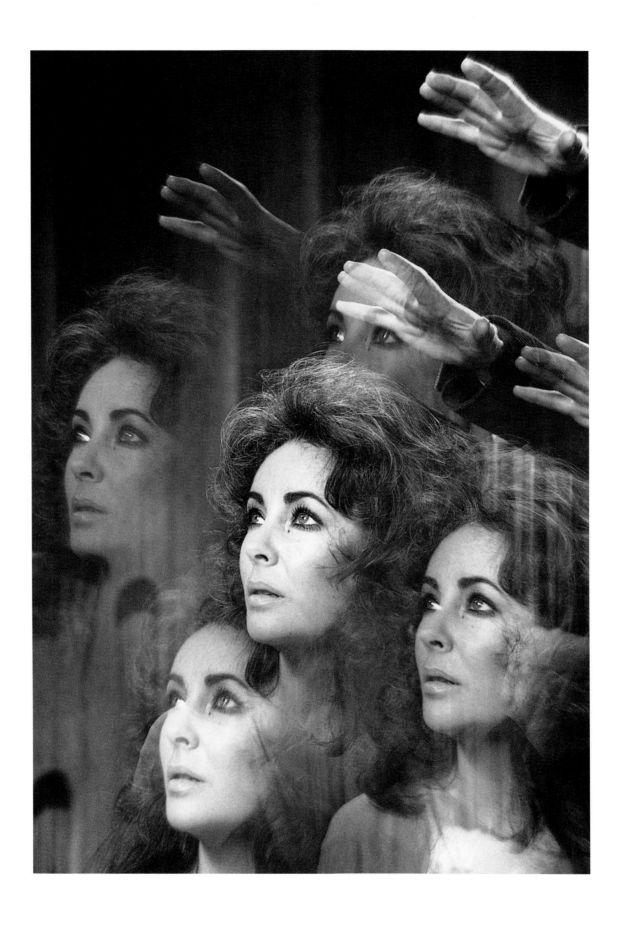

76 ELIZABETH: "THAT MAN HAS A PROBLEM. HE HAS A SMALL . . . !"
DON'T ASK ME THE TITLE OR THE DATE OF THE FILM.

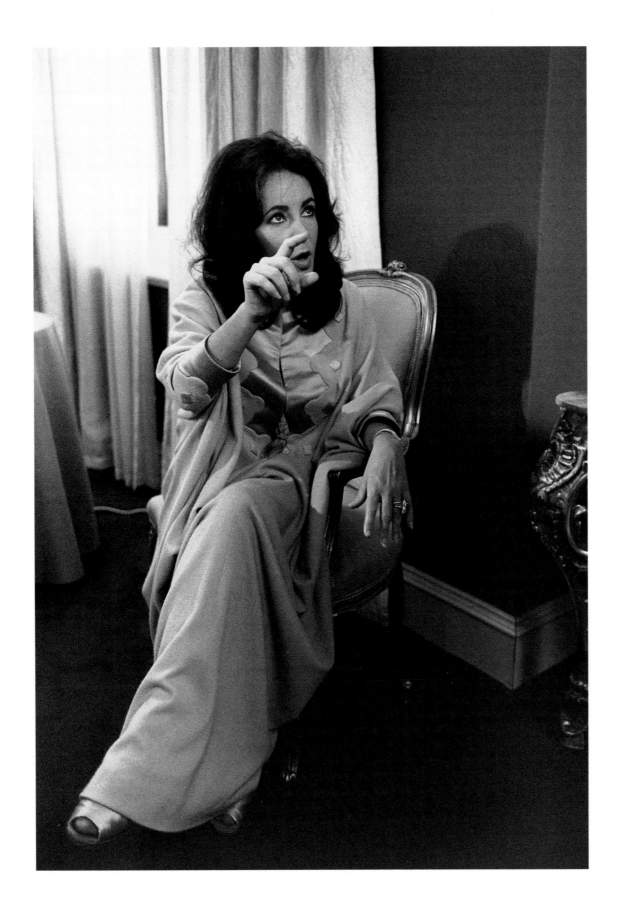

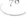

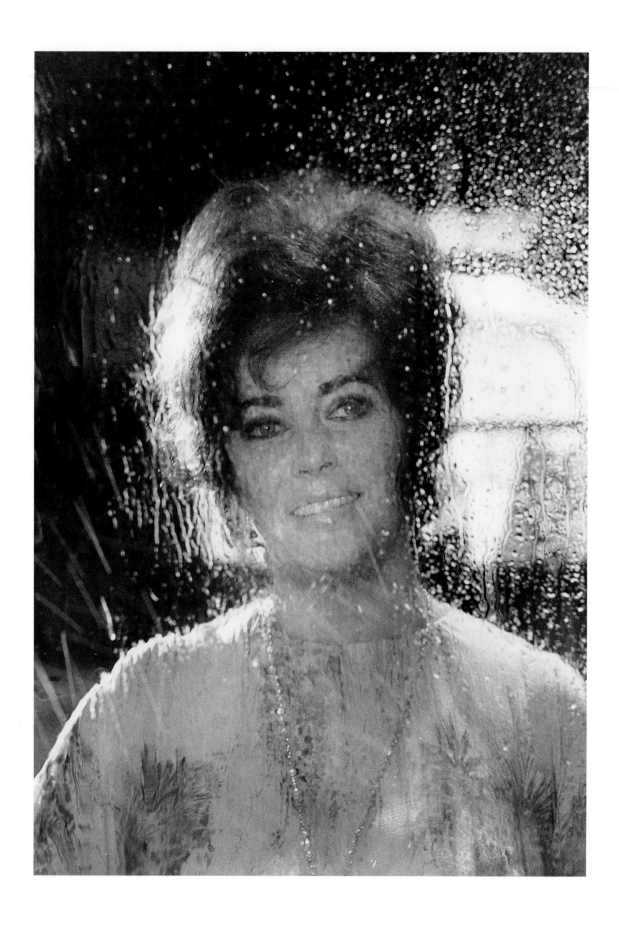

I DON'T WANT TO TIP THE SCALES AGAINST ME, BUT YOU ARE MUCH SWEETER THAN I AM.

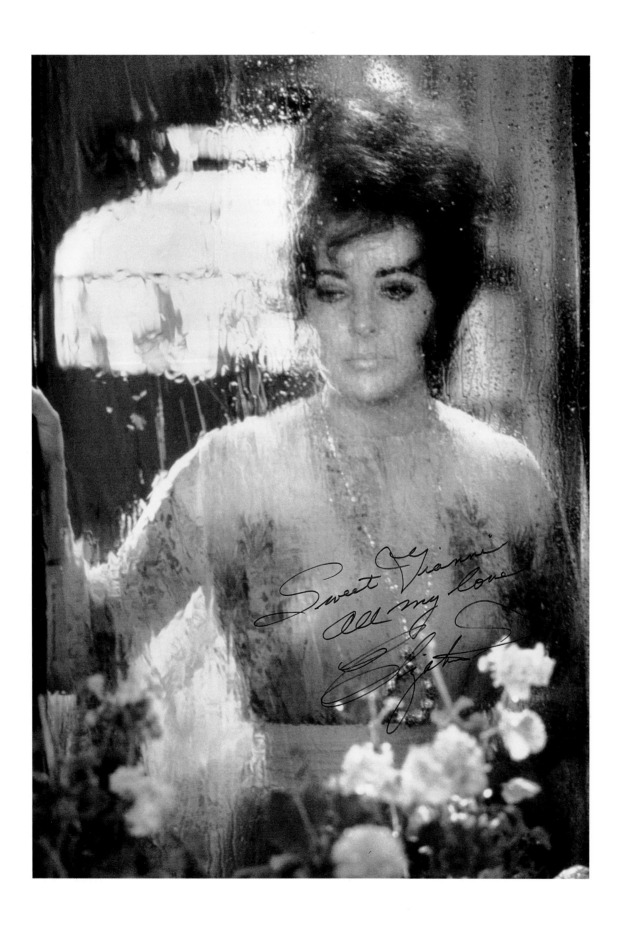

CORTINA D'AMPEZZO, ITALY, 1973. AFTER HER HAIR IS CURLED UNDER A STOCKING CAP, IT'S TWISTED AND TIGHTENED AND THEN COVERED BY THE TURBAN, EASILY DISSOLVING THE FORCES OF GRAVITY. ELIZABETH WITH HENRY FONDA, HER HUSBAND IN THE FILM *Ash Wednesday.*

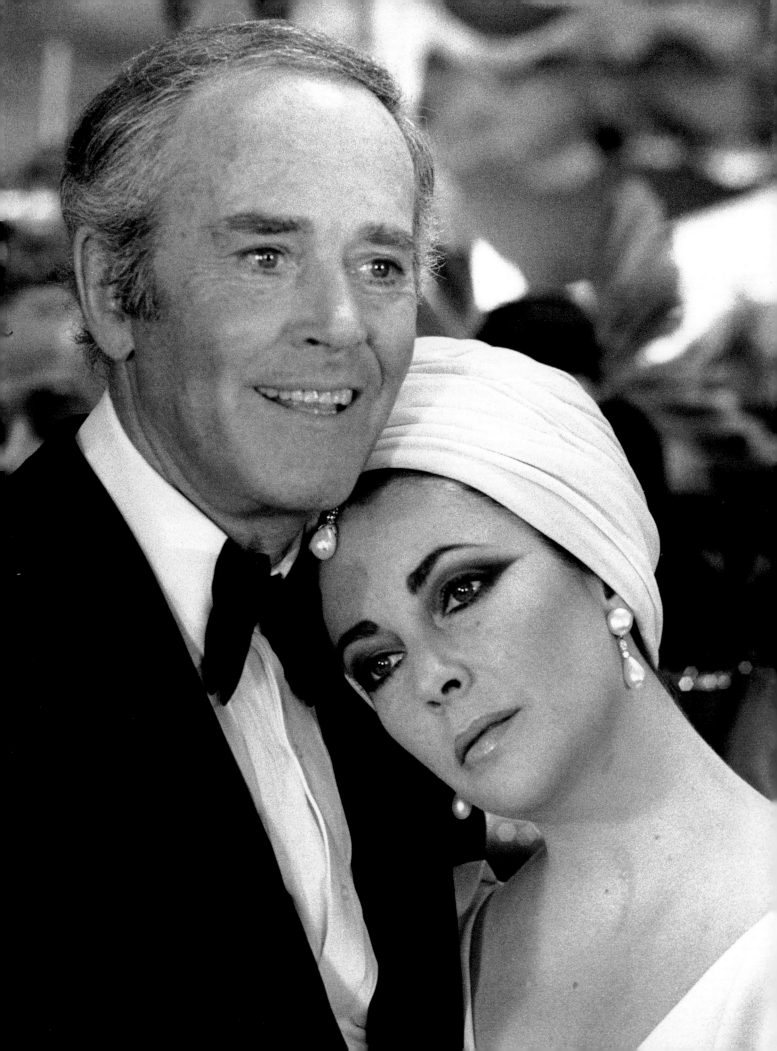

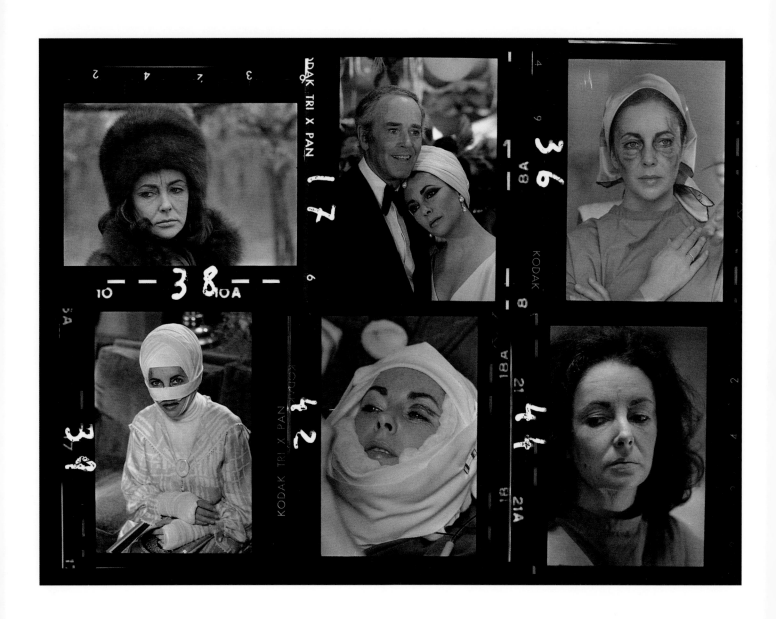

above and following pages TREVISO, ITALY, 1973. FICTION OR REALITY?

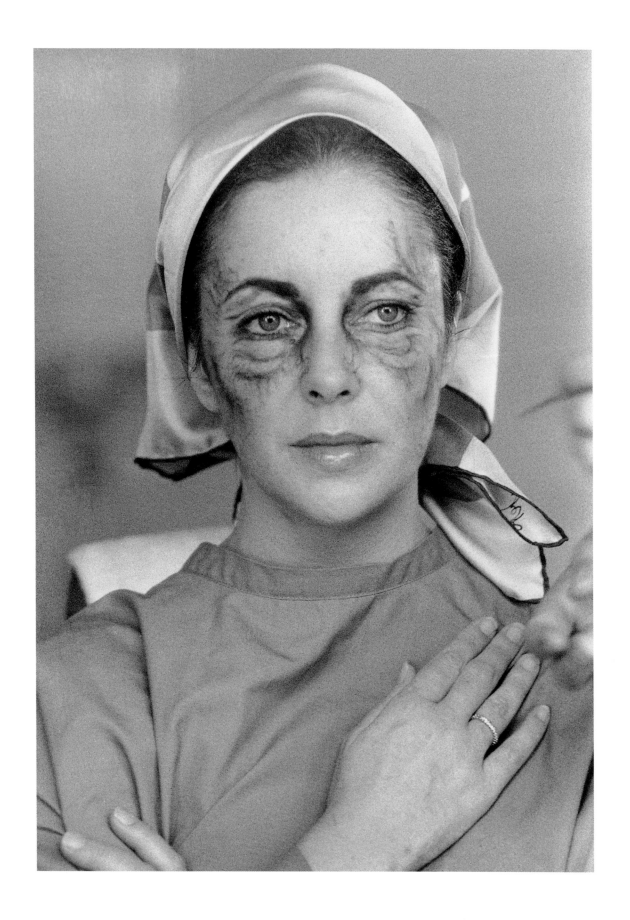

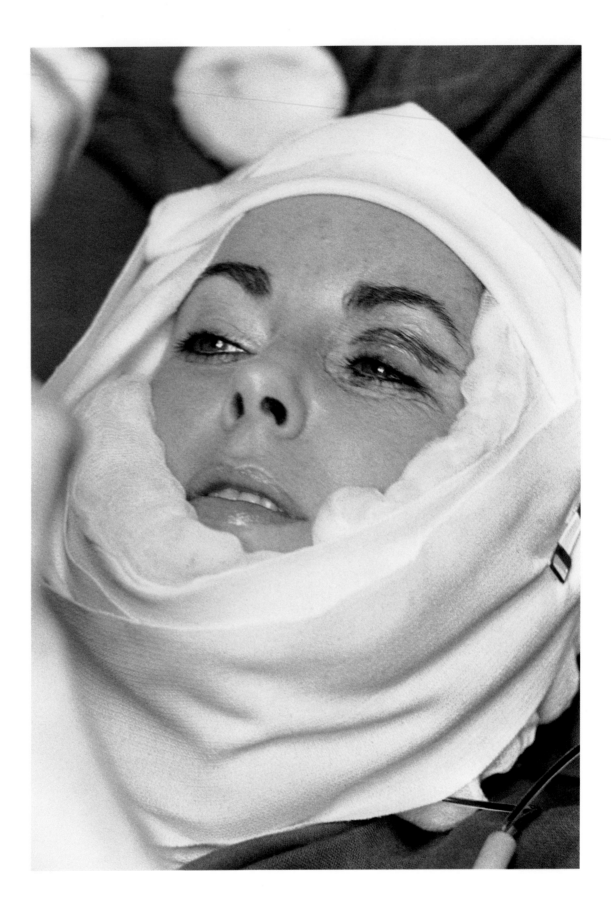

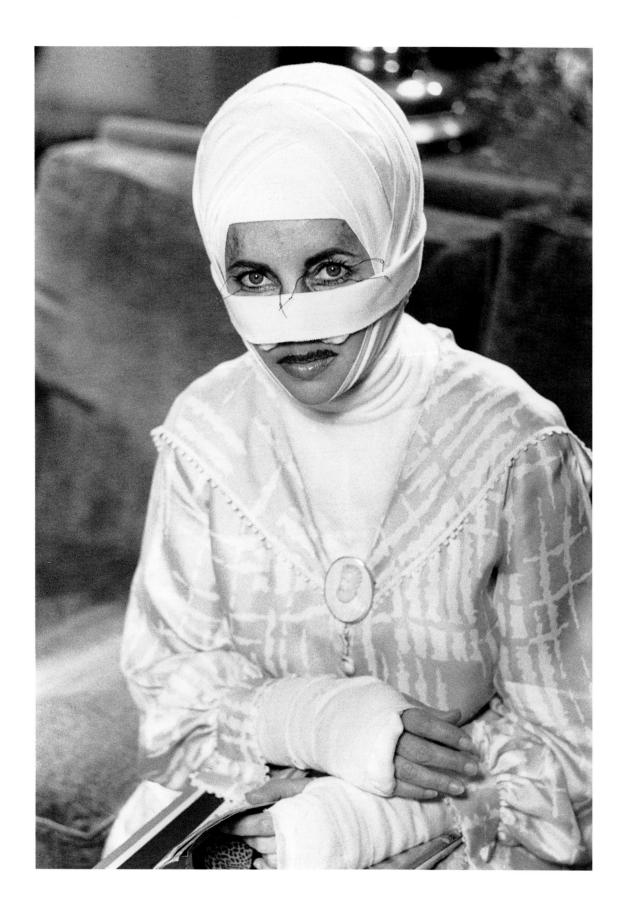

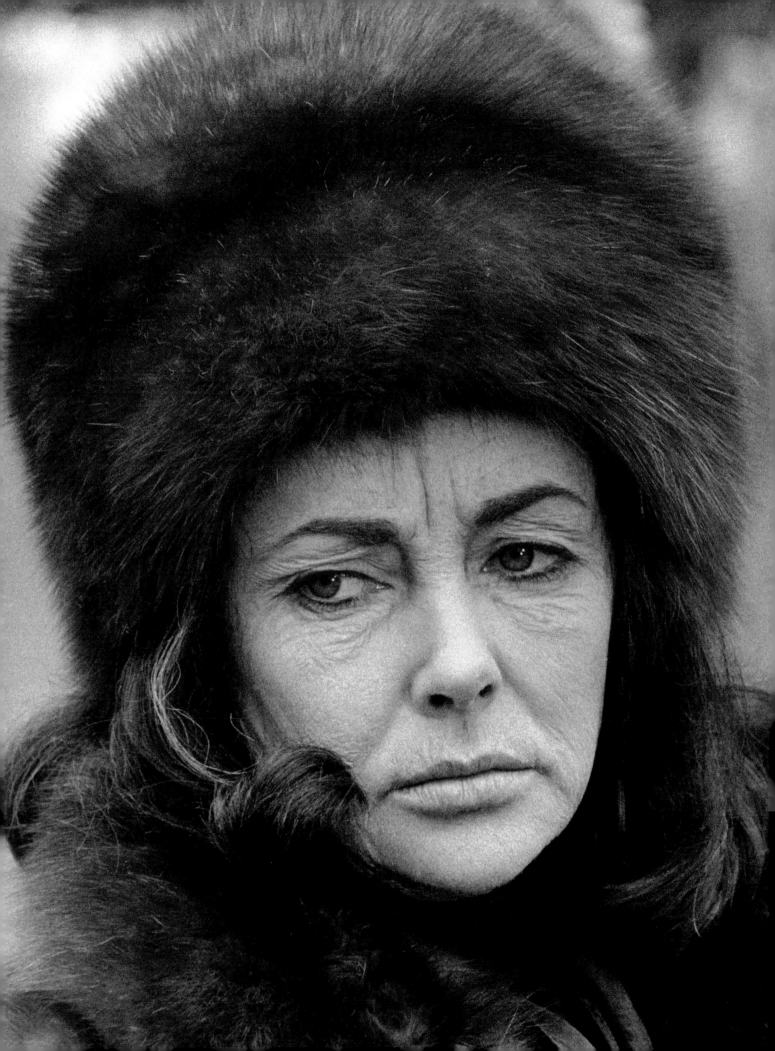

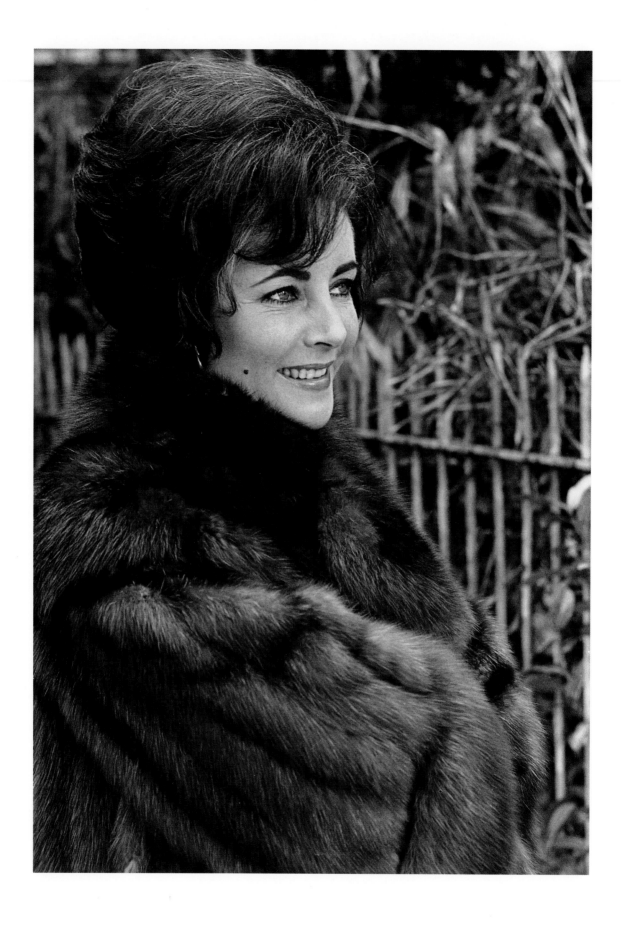

A SHAME! MAKEUP BY THE GREAT ALBERTO DE ROSSI FOR *Ash Wednesday*.

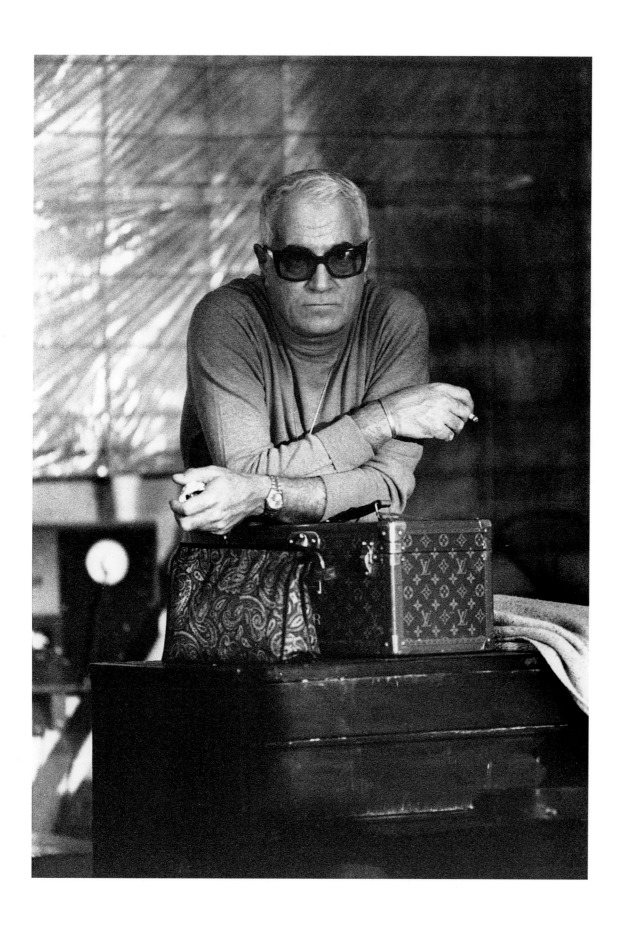

89

ALBERTO DE ROSSI, THE MAKEUP ARTIST MOST LOVED BY THE DIVAS—
IN EVERY SENSE OF THE WORD. I WAS LIKE A SON TO HIM.

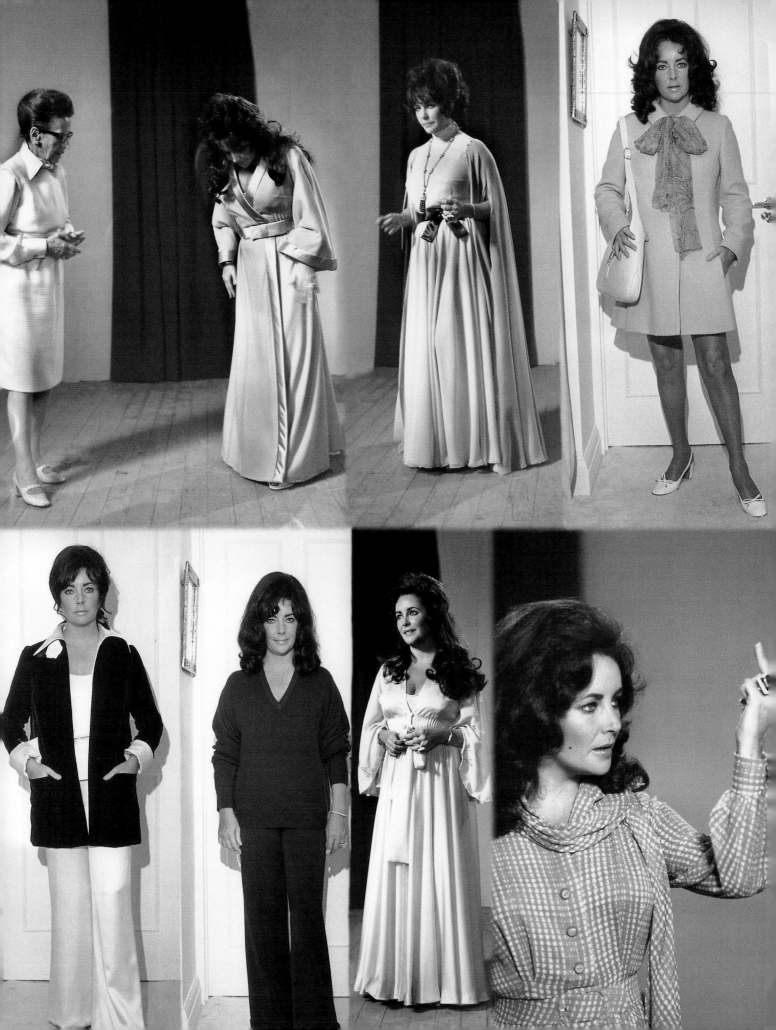

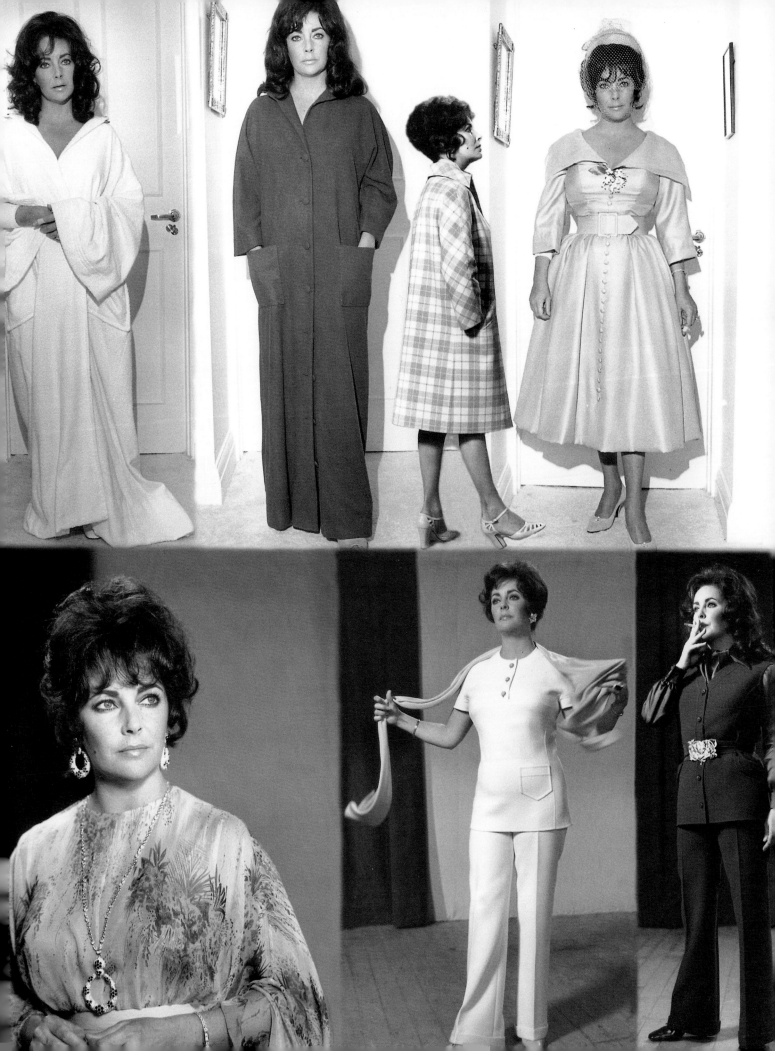

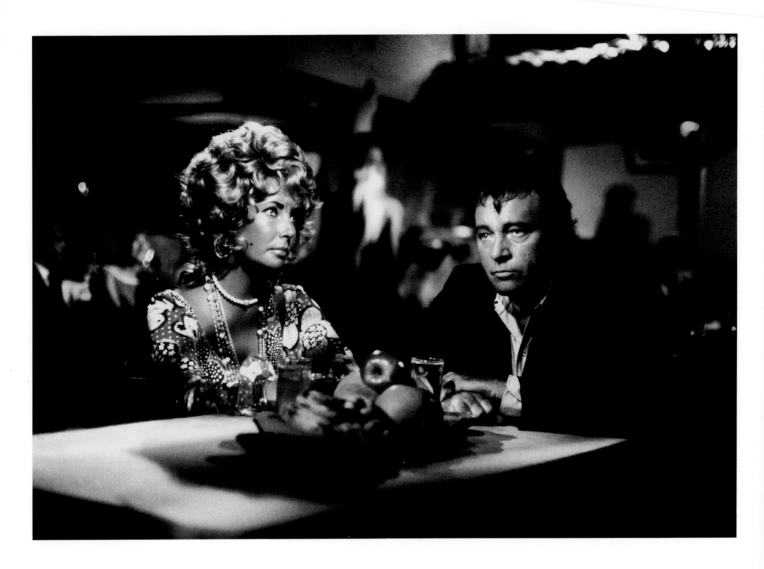

ACAPULCO, MEXICO, 1972. ELIZABETH TAYLOR AS A BLOND, DITZY WAITRESS WITH R. B. IN VARIOUS SCENES OF THE FILM *Hammersmith Is Out*. FROM A WAITRESS TO A PREGNANT WOMAN TO A WIDOW. DURING THIS FILM, A LABORATORY IN MEXICO HAD PLANS OF SABOTAGE—THEY ALMOST DESTROYED ALL OF THESE NEGATIVES FOR THE PAPARAZZI'S BENEFIT.

preceding pages
BEVERLY HILLS, CALIFORNIA, 1973. A COSTUME TEST FOR *Night Watch* WITH THE GREAT EDITH HEAD, COSTUME DESIGNER AND MULTIPLE OSCAR AWARD WINNER. WHEN BRIAN HUTTON, THE DIRECTOR, ASKED E. T. TO START ALL OVER AGAIN AFTER A LONG DAY OF TRYING ON COSTUMES, ELIZABETH RESPONDED BY SHOWING HIM HER RING.

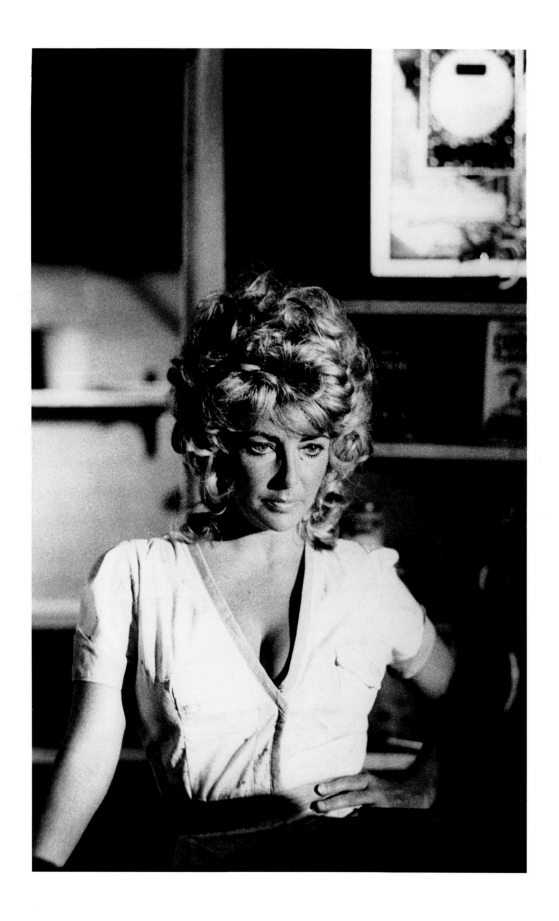

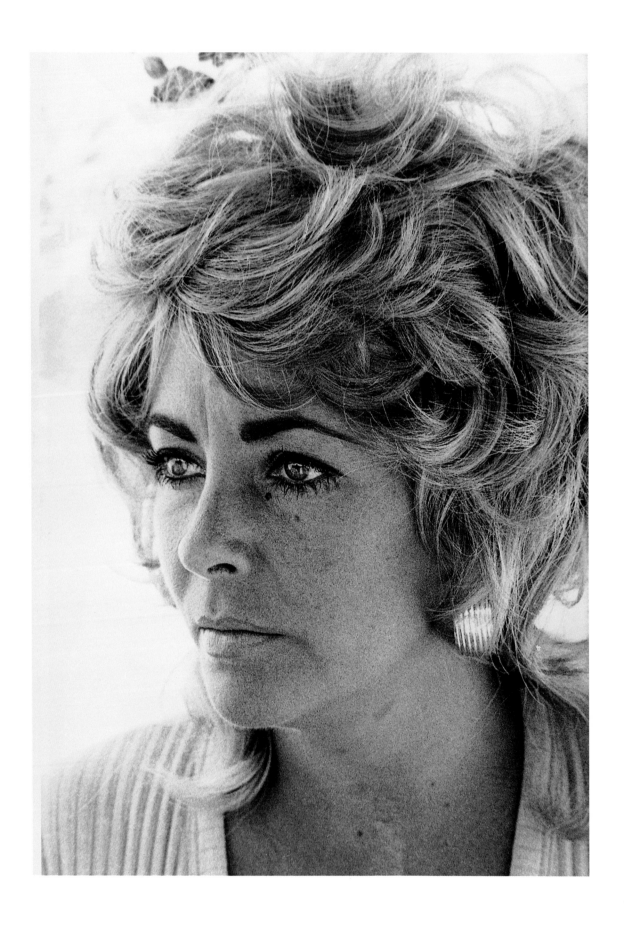

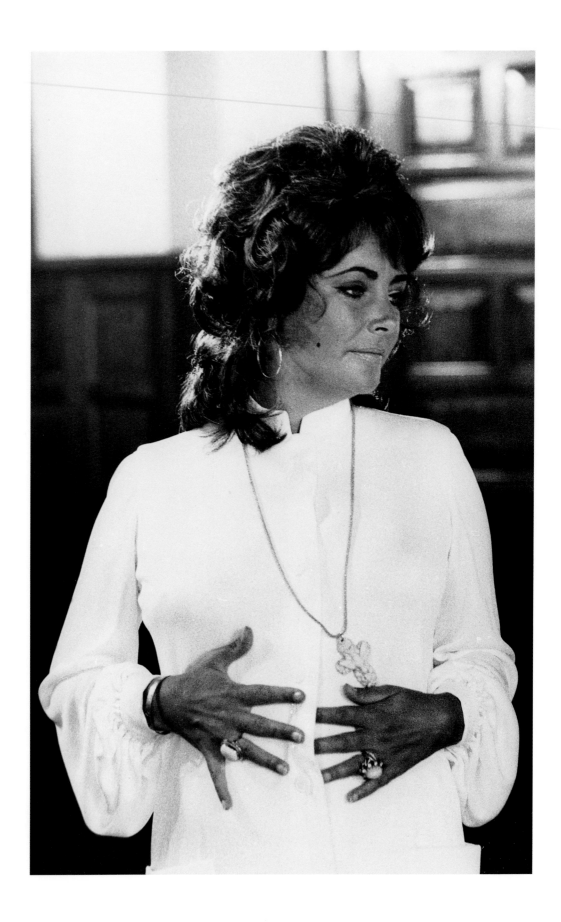

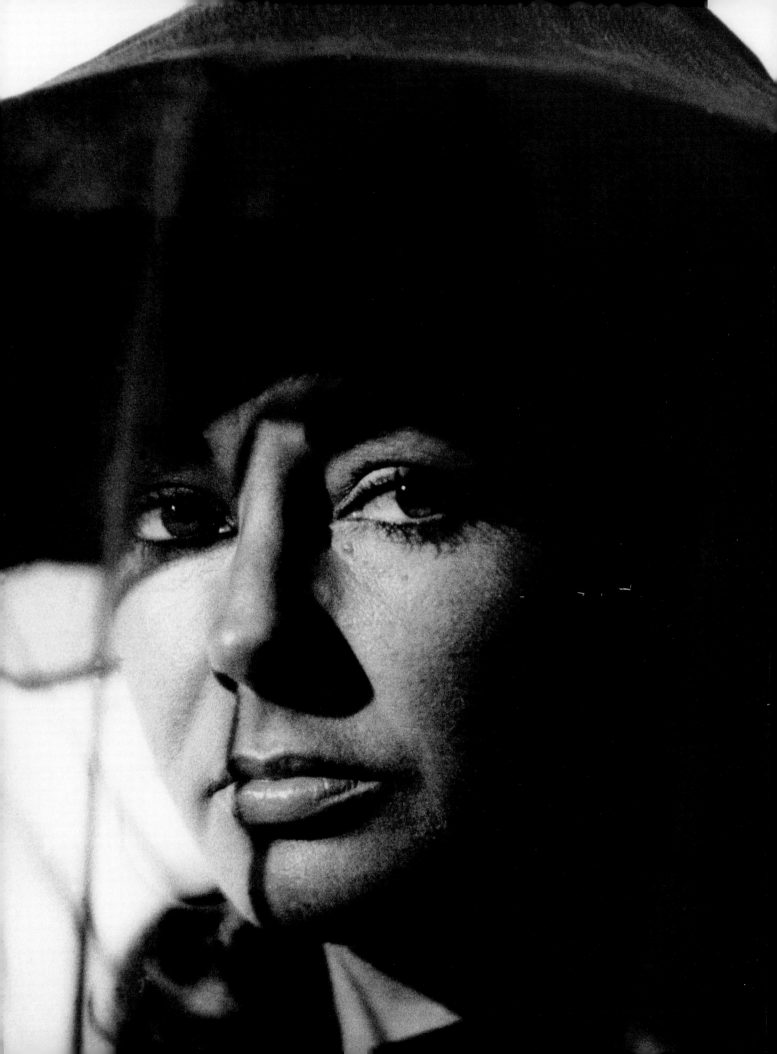

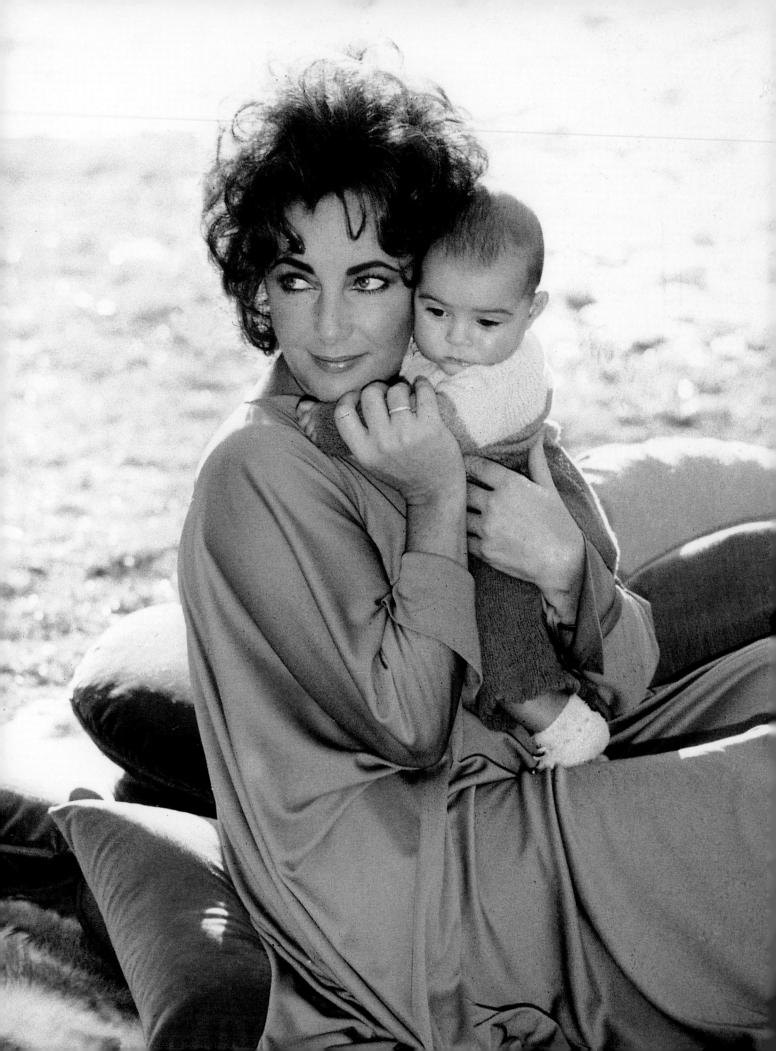

Part 3

PRIVATE LIFE, FAMILY, AND FRIENDS

n the 1960s and early 1970s, I photographed countless actors and actresses, many rock stars (including the Beatles), top fashion models, and leaders of governments from Monaco to Iran to Yugoslavia. For a long time, I resented being known as "Elizabeth Taylor's photographer," because that was only a fraction of my work.

I owe it to my second wife, Kelley Vander Velden, that I am more comfortable and proud of my past work today. For many years I had the photographs stashed away, and I didn't even talk about my life and times with Elizabeth and Richard. But Kelley, a model and actress whom I directed in one picture, *I Love New York,* was an artist. She inquired into my past and took out the photographs and dusted them off, reminding me of their value and importance.

When Kelley died in November 1998, Elizabeth got in touch with me. She sent flowers with a loving note. I spoke to her on the telephone. She was wonderfully caring, as I know

her always to be. I am ashamed to say that I had not spoken to Elizabeth for a long time. There had been marriages and divorces. Elizabeth was virtually out of the film business, and I lived a different life and was a different person, maybe.

The phone call took me back to when we were making *The Only Game in Town*, a comedy with Elizabeth and Warren Beatty, I remember hanging out in the corridor outside her dressing room one day—as I often did—when the door swung open to Elizabeth's scream. There was her makeup man, Frankie Larue, furious at Elizabeth (which wasn't too unusual), threatening to kill her and holding a huge pair of scissors in his hand (slightly more unusual). As I leaped in, Frankie whirled to stab me, and I punched him on the chin and knocked him down and out, into the hallway. After that, Elizabeth always called me "Gangster." Just to retaliate, I always called her "Baby Boobs."

When Elizabeth phoned me after Kelley died, she asked to meet my daughter, Rhea Bianca, so I brought her to Los Angeles to meet this legend of show business so intertwined with my life. After hugging my daughter, Elizabeth turned to hug me. "How are you, Baby Boobs?" I asked. "Gangster," she said. At that moment—and ever since, because we are back in regular touch—it was as if no time had passed.

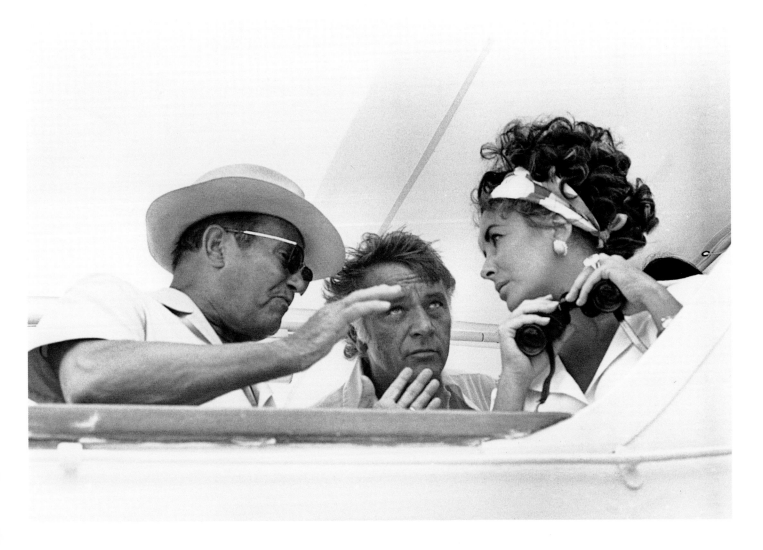

1970. Elizabeth and Richard with a casually dressed Yugoslavian president Marshal Tito on his ship—I say ship because it was at least 150 meters (450 feet) long. They sailed along the coast, and the Burtons marveled at how much Tito was loved and applauded by sunbathers along the coast. To Elizabeth I said, "who knows how much he paid them?" I believe she's still laughing about it.

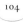

104

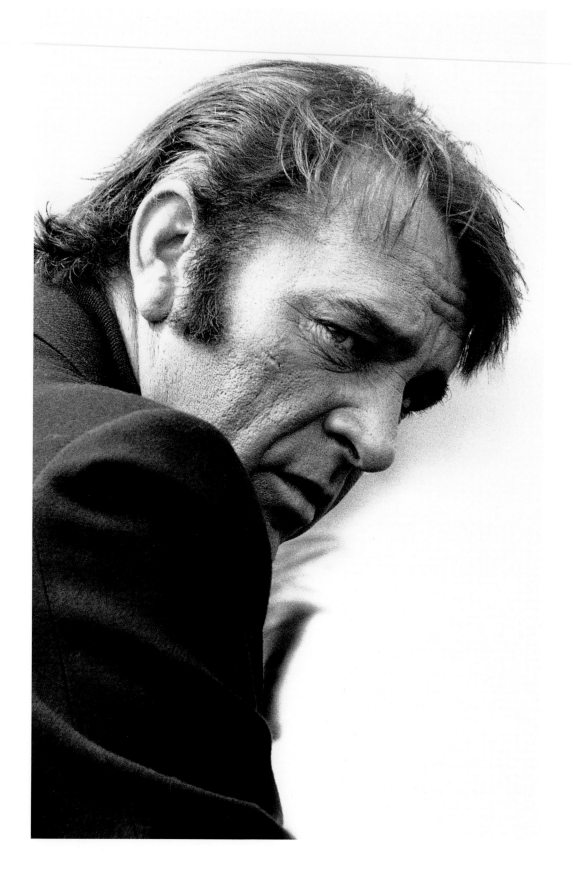

Oxford, 1966. Big Richard! This is the photograph that Elizabeth chose for autographs.

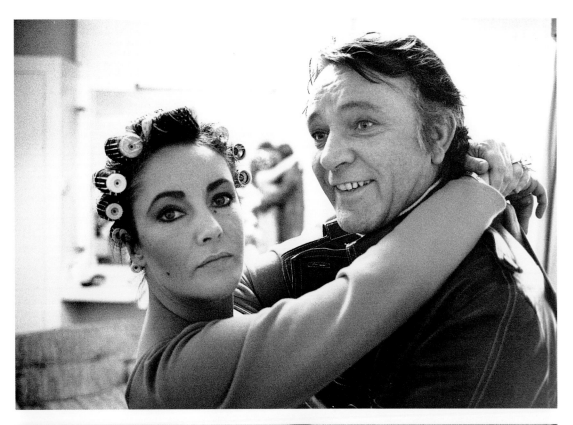

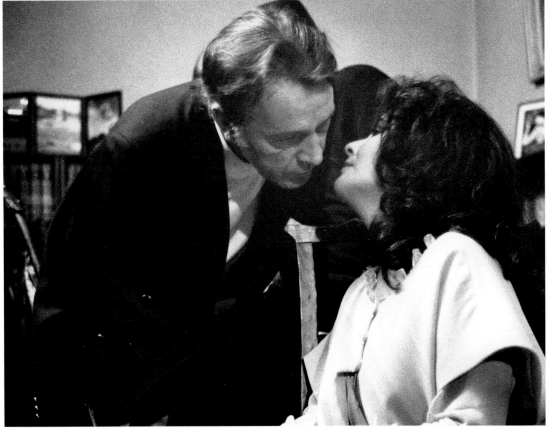

WHENEVER ELIZABETH WAS WORKING AND HE WAS NOT, THINGS WEREN'T ALWAYS ROSY. USUALLY HE WOULD DRINK TOO MUCH, BUT THEY LOVED EACH OTHER ANYWAY.

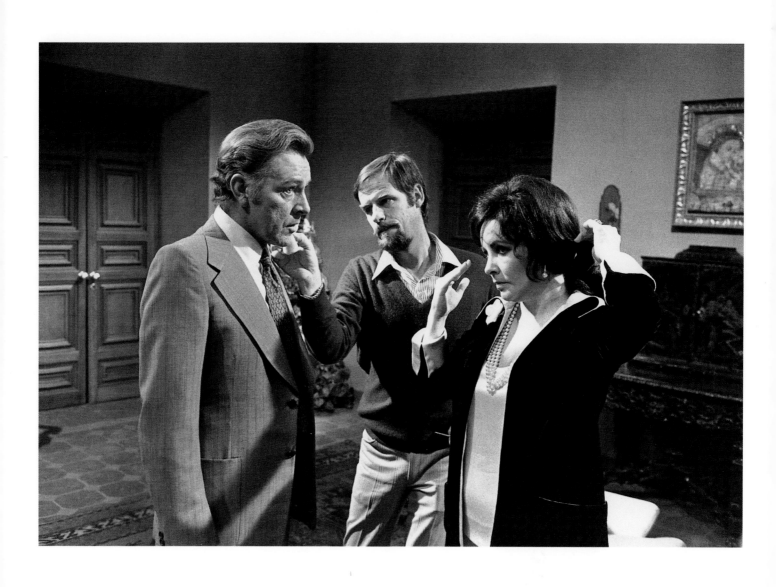

IDEALLY THEY WOULD WORK TOGETHER AS MUCH AS POSSIBLE. BUT ONE DAY RICHARD TOLD ME:
"IF WE DON'T STOP WORKING TOGETHER, WE'LL END UP LIKE LAUREL AND HARDY."

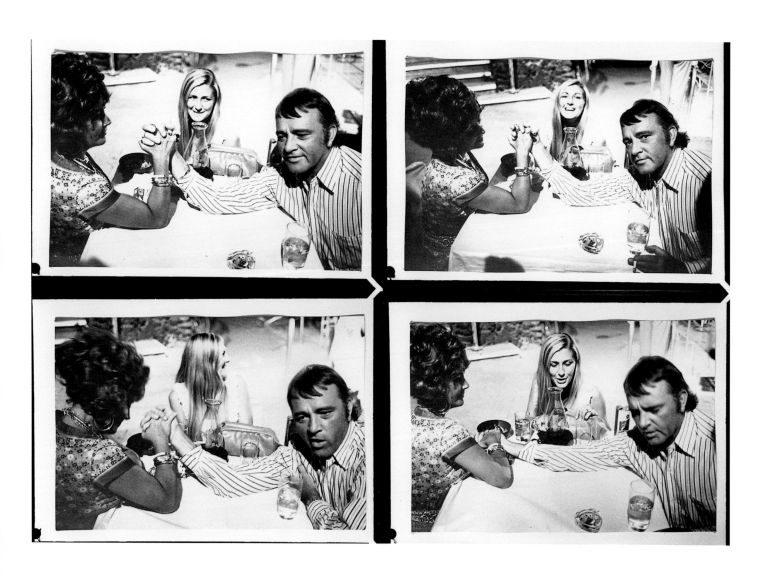

QUARGUALE, CORSICA, 1969. RICHARD: "NO MATTER WHAT, SHE ALWAYS WINS."

opposite and following pages
Happy and relaxed. Puerta Vallarta was magical for both of them.
Jokingly, I often called her "Baby Boobs." I don't think I am mistaken.

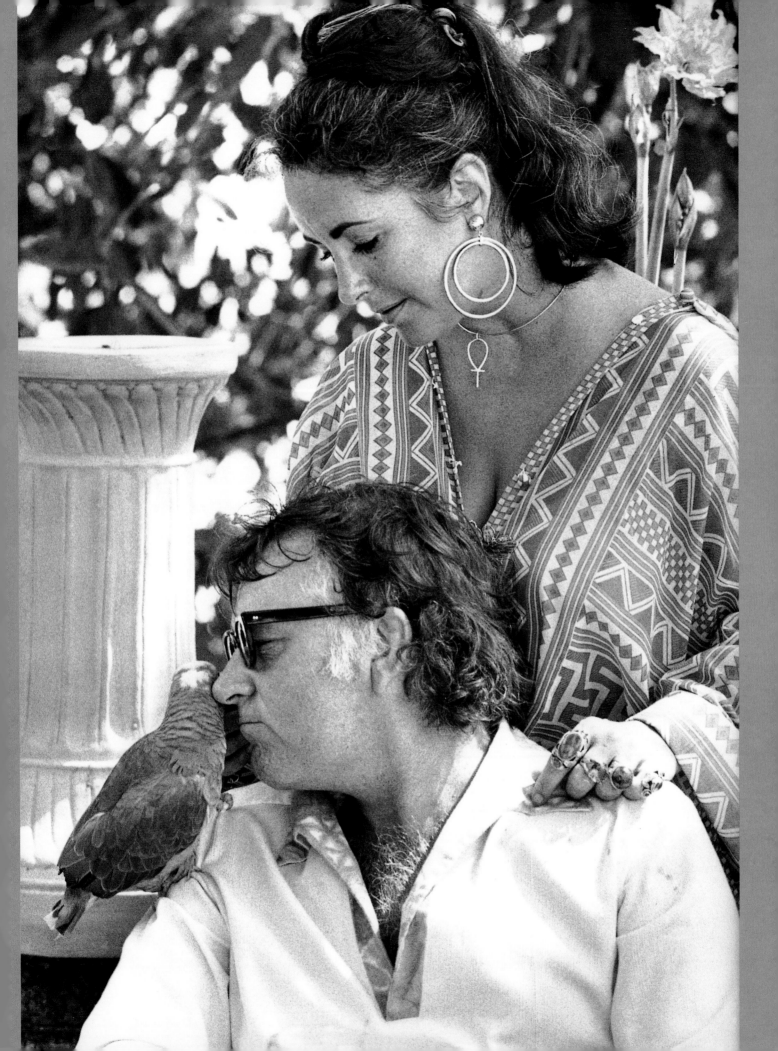

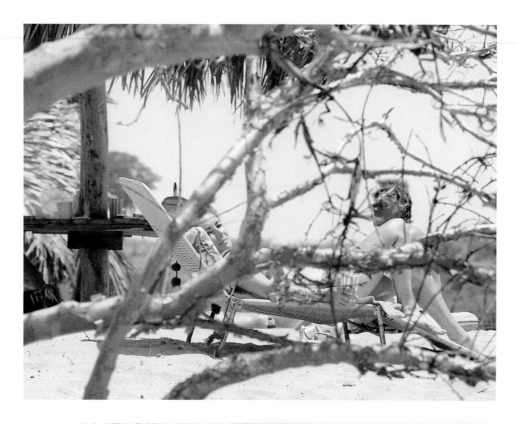

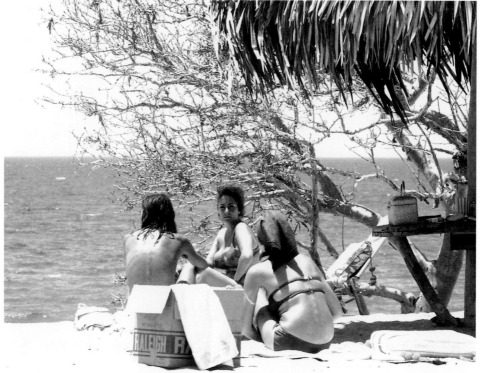

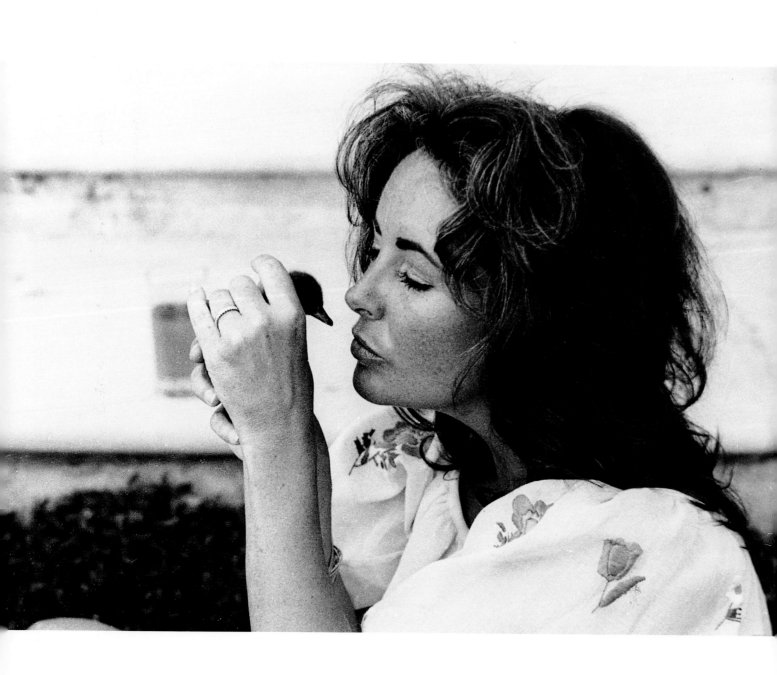

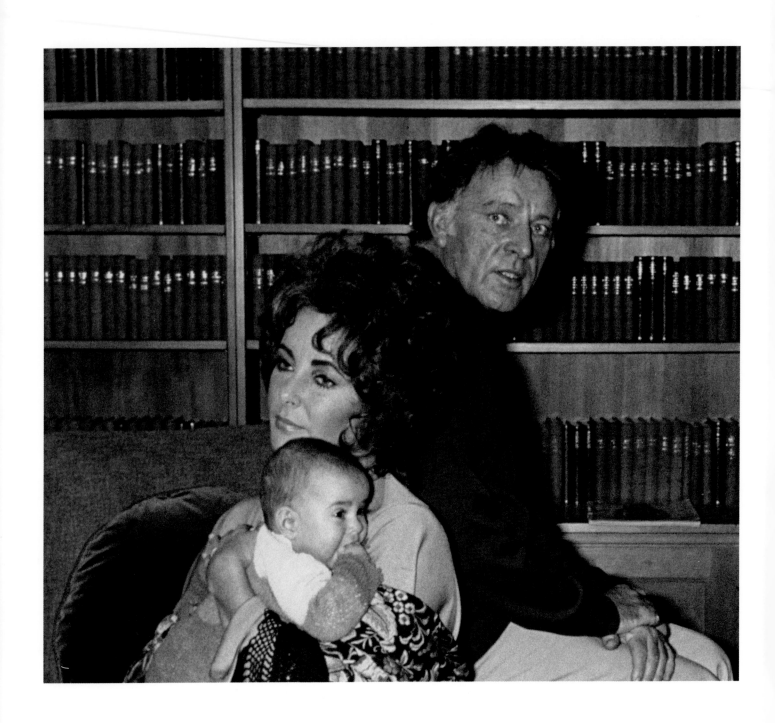

GSTAAD, SWITZERLAND, 1971, CHALET ARIEL. HERE, ELIZABETH WAS NOW A GRANDMOTHER, AND RICHARD SAID: "I MARRIED A BABE, AND I FIND MYSELF HERE WITH A GRANDMA." I DON'T THINK HE REALLY THOUGHT THAT WAY, BUT FROM THIS EXPRESSION ONE ISN'T REALLY SURE.

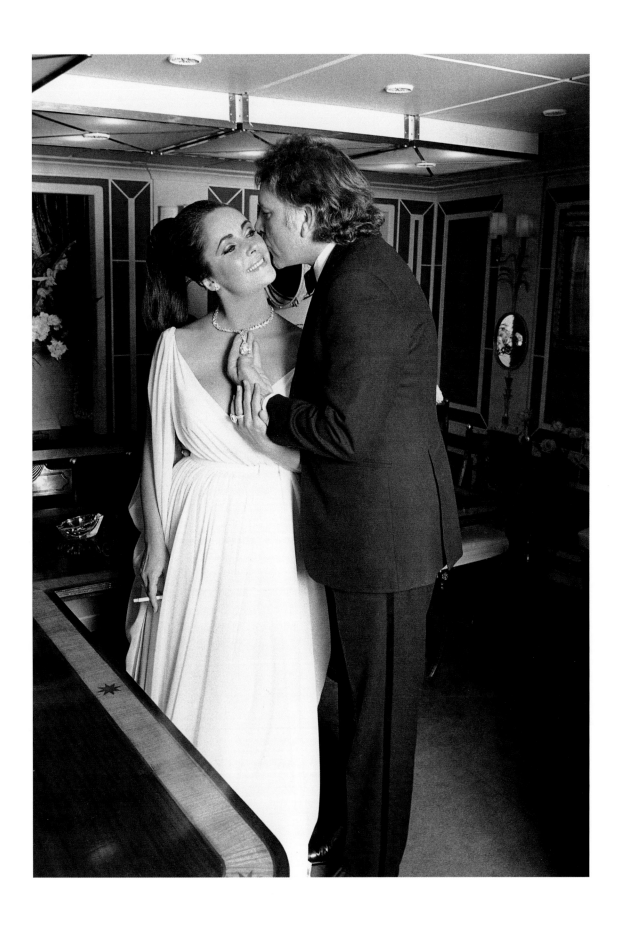

PORTOFINO, ITALY. ON BOARD THE *Kalizma*, RICHARD SHOWS ME THIS LITTLE
SIXTY-NINE-CARAT ROCK—"THE CARTIER TAYLOR/BURTON DIAMOND."

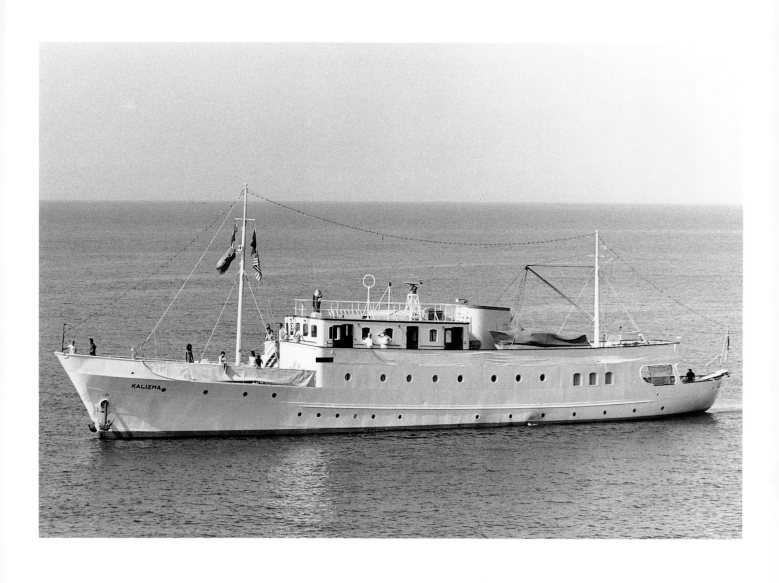

PORTOFINO, ITALY. IN THIS PHOTOGRAPH OF THE *Kalizma*, YOU CAN CATCH A GLIMPSE OF THE
ENTIRE FAMILY, INCLUDING LITTLE LEILA.

HELICOPTERS AND PRIVATE AIRPLANES. WHEN RICHARD EMERGED FROM THE AIRPLANE IN
PARIS, A WOMAN GOT CLOSE TO HIM AND ASKED: "MR. TAYLOR, MAY I HAVE AN AUTOGRAPH?"
RICHARD SIGNED IT *Richard Taylor.* WHO KNOWS HOW VALUABLE THAT AUTOGRAPH IS TODAY?

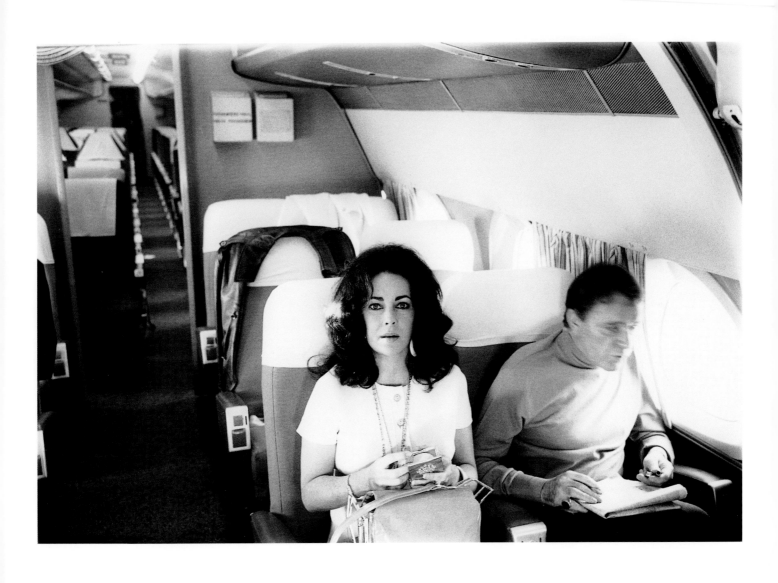

TAORMINA, SICILY, 1972. ALONE IN A PLANE, E. T. AND R. B. ON THEIR WAY TO TAORMINA
FROM LONDON TO RECEIVE IL DAVID DI DONATELLO, THE ITALIAN AWARD FOR FILM WORK.

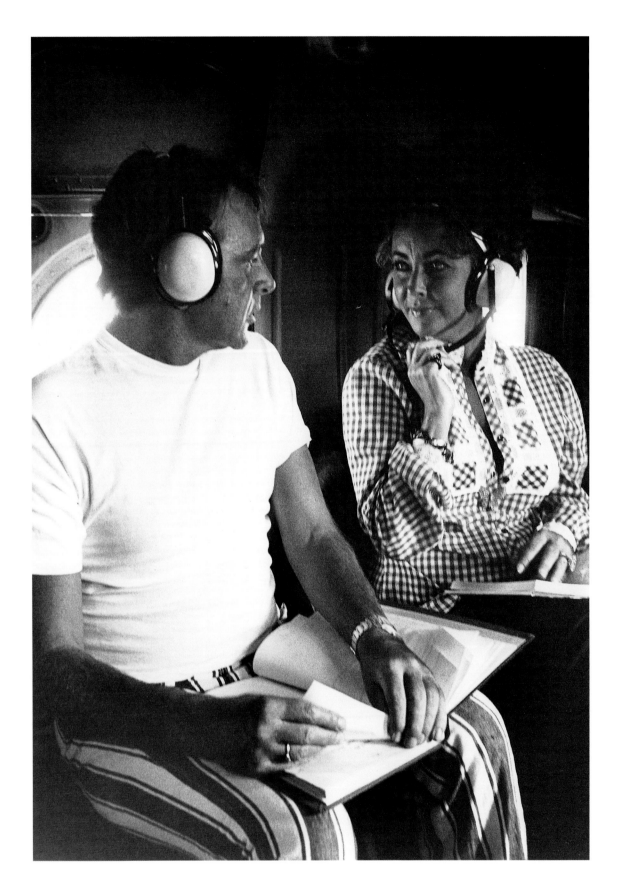

117

Sarajevo, 1970. That day God was with us. We were traveling in a helicopter through the mountains under clear blue skies when we came upon a cloud of such density that visibility was reduced to zero. We were saved by a miracle, enough for us to want to kiss the ground after we landed.

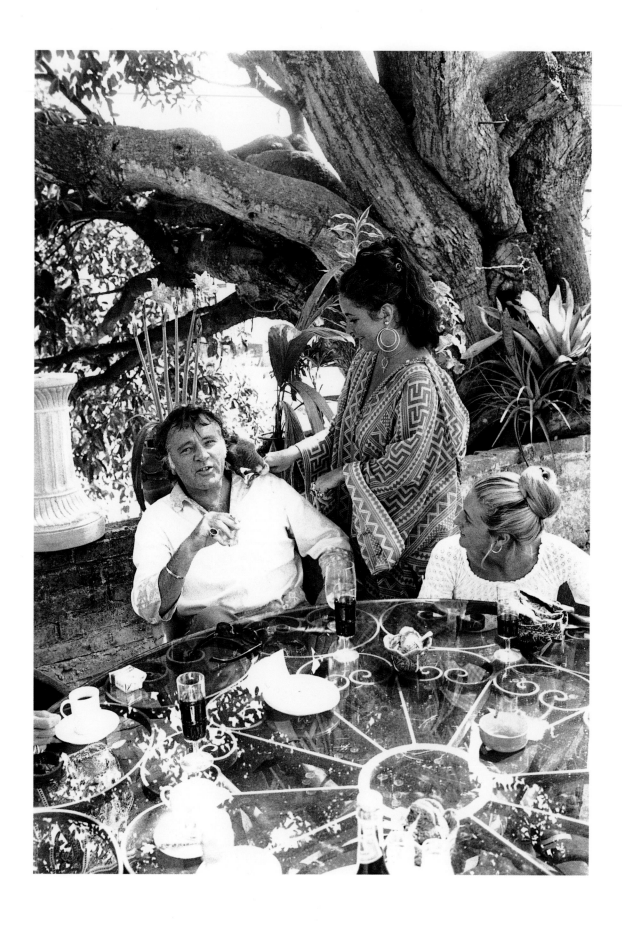

Acapulco, Mexico, 1971. Elizabeth and Richard with my first wife Claudye, playing with a parrot that spoke only Spanish.

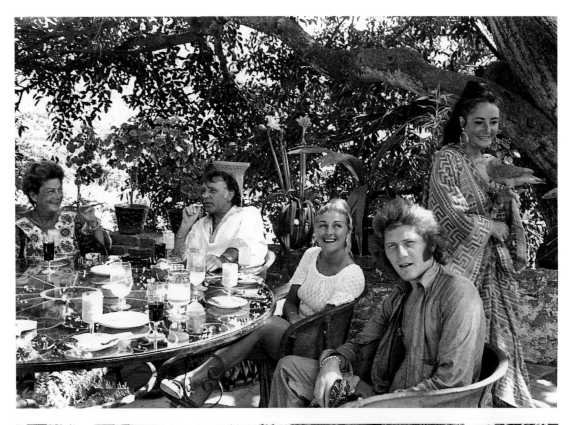

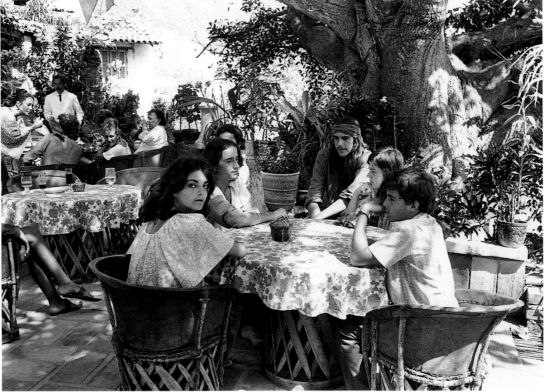

HE THEN PROCEEDED TO POSE ON MY SHOULDER WHERE HE DEPOSITED A LITTLE . . .
SOMETHING (OUR GROUP IS IN THE UPPER LEFT CORNER OF THE BOTTOM PHOTO).

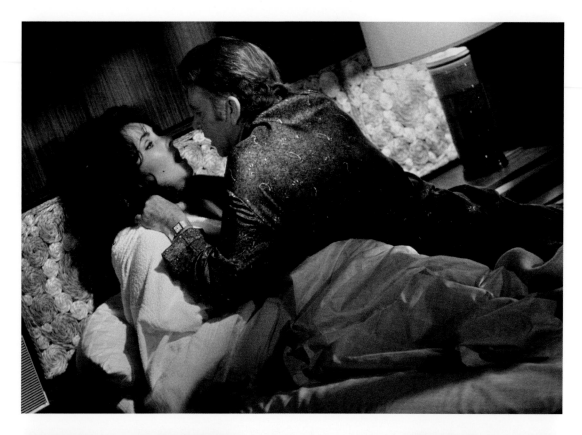

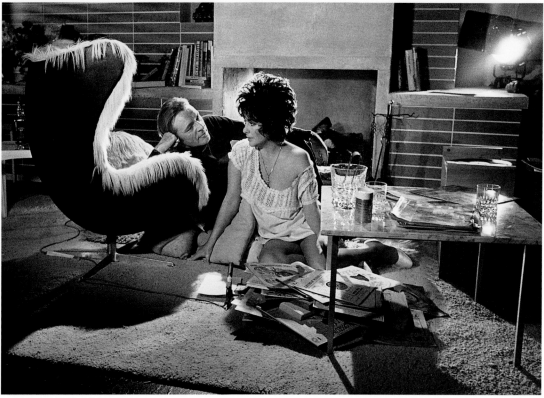

120

RICHARD HAD ALWAYS DESCRIBED THEIR MARRIAGE AS "A GREAT LOVE AND
TUMULTUOUS PASSION."

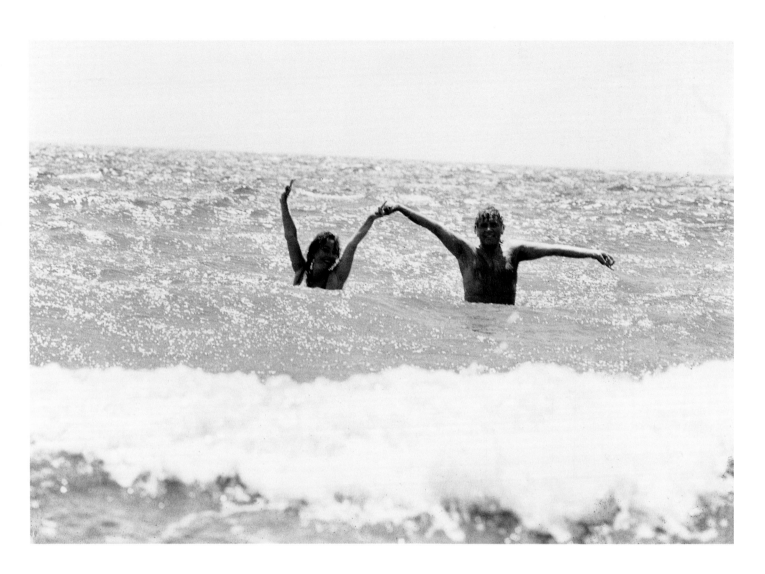

WE ARE IN BUSSERIA ON THEIR PRIVATE BEACH NEAR PUERTO VALLARTA. THEY ARE PLAYING WITH ME, BUT UNFORTUNATELY THAT DAY I DIDN'T HAVE MY USUAL CAMERA WITH ME, ONLY A LITTLE MINOLTA.

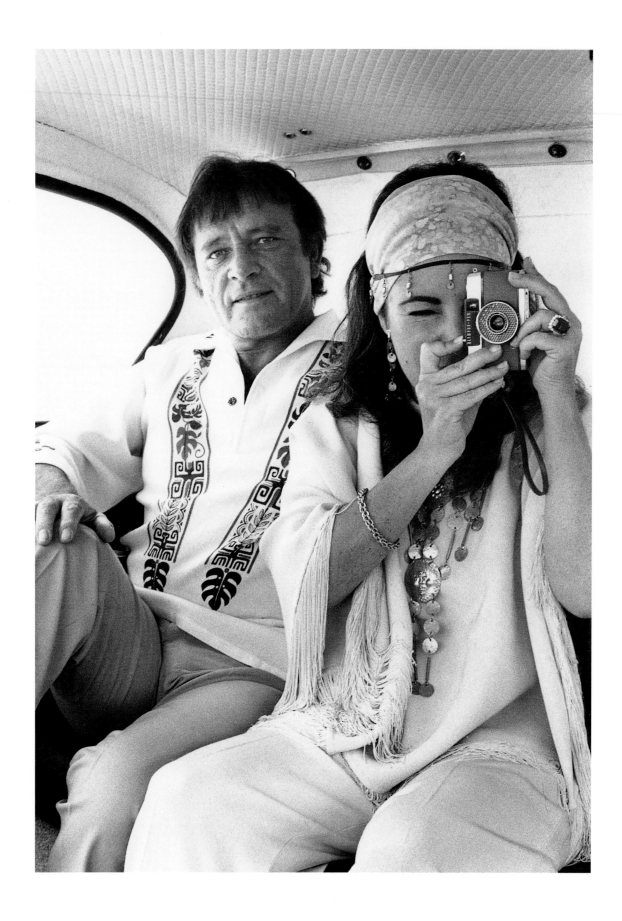

122

PORTOFINO, ITALY. THE PHOTOGRAPHER AND THE STAR IMMORTALIZED BY THE DIVA.
RICHARD DIDN'T WANT ME TO MAKE COPIES OF THAT PHOTOGRAPH.

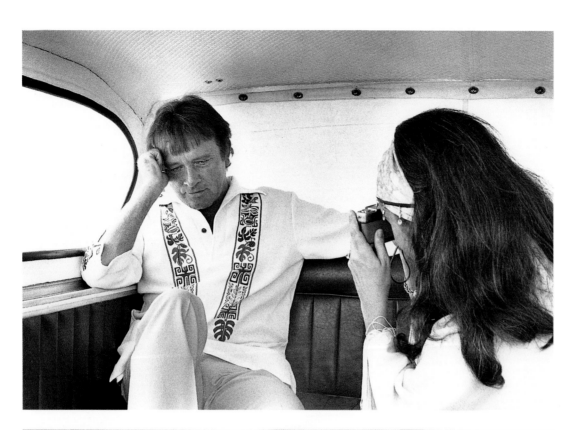

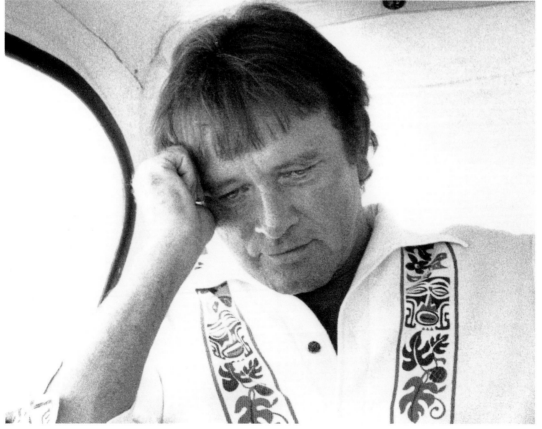

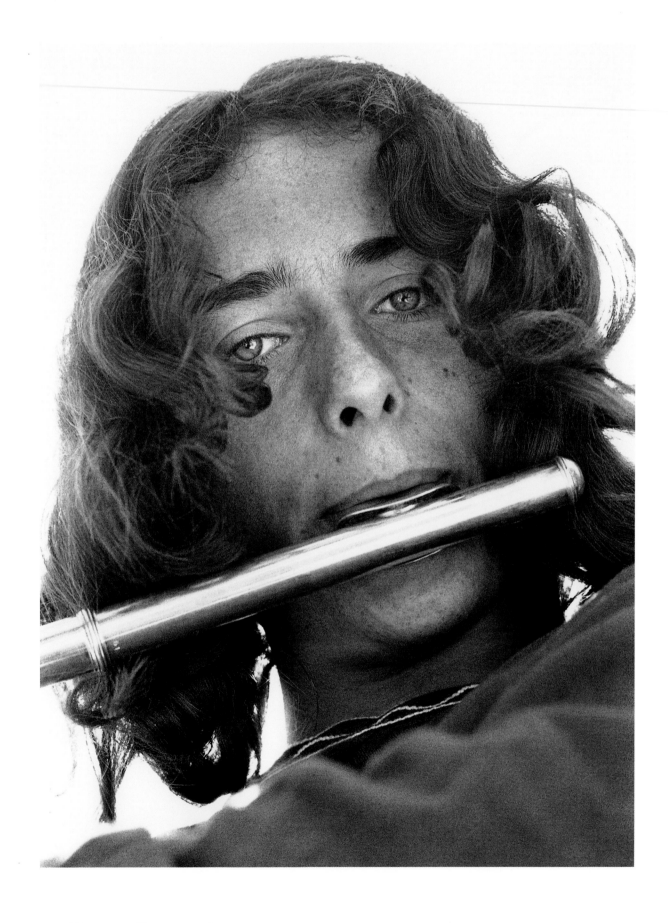

CHRISTOPHER WILDING, ELIZABETH'S SECOND BORN, AGE FIFTEEN,
PLAYING HIS FAVORITE INSTRUMENT. HE INHERITED HIS MOTHER'S EYES.

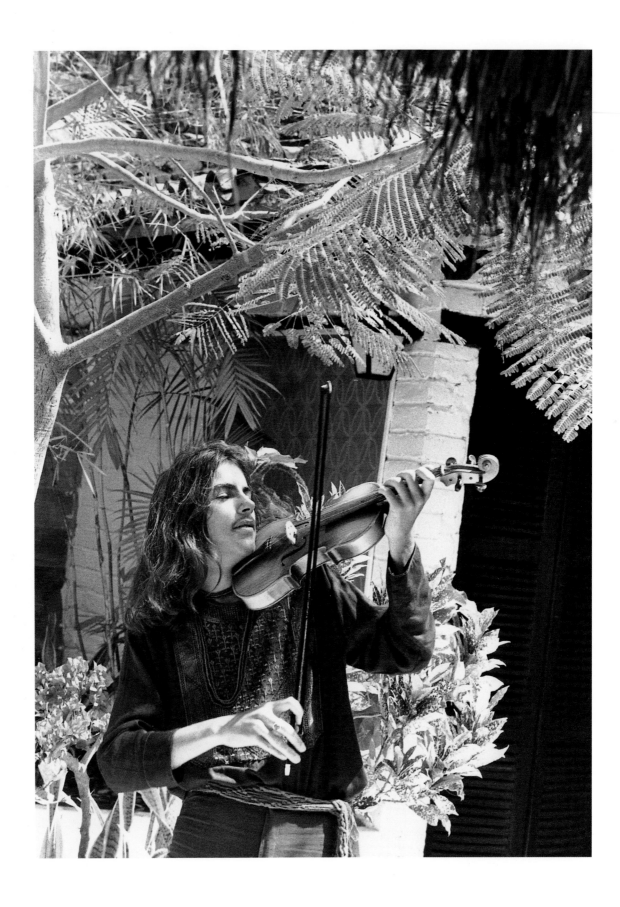

126

MICHAEL WILDING, THE FIRST BORN, AGE SEVENTEEN, WITH HIS INSTRUMENT.

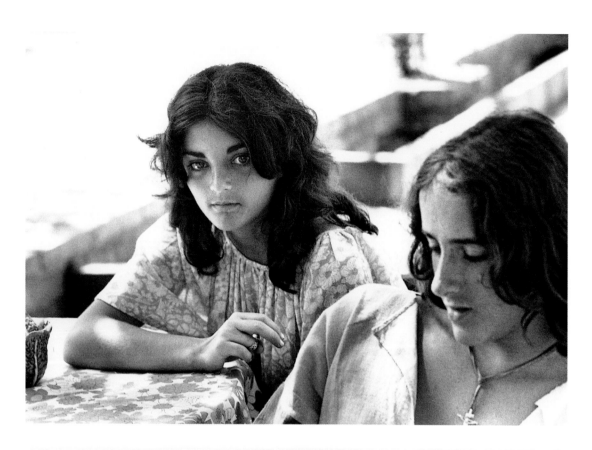

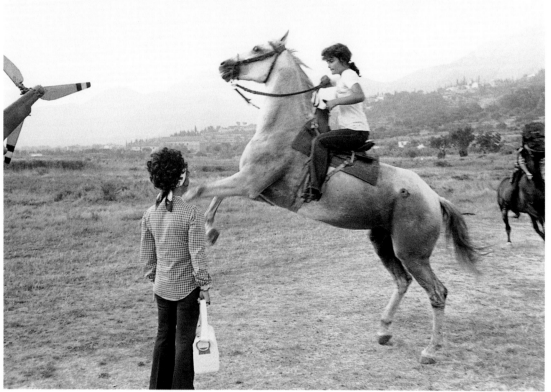

LIZA TODD, AGE THIRTEEN, WITH HER FATHER'S EYES. HER GREAT PASSION—HORSES.

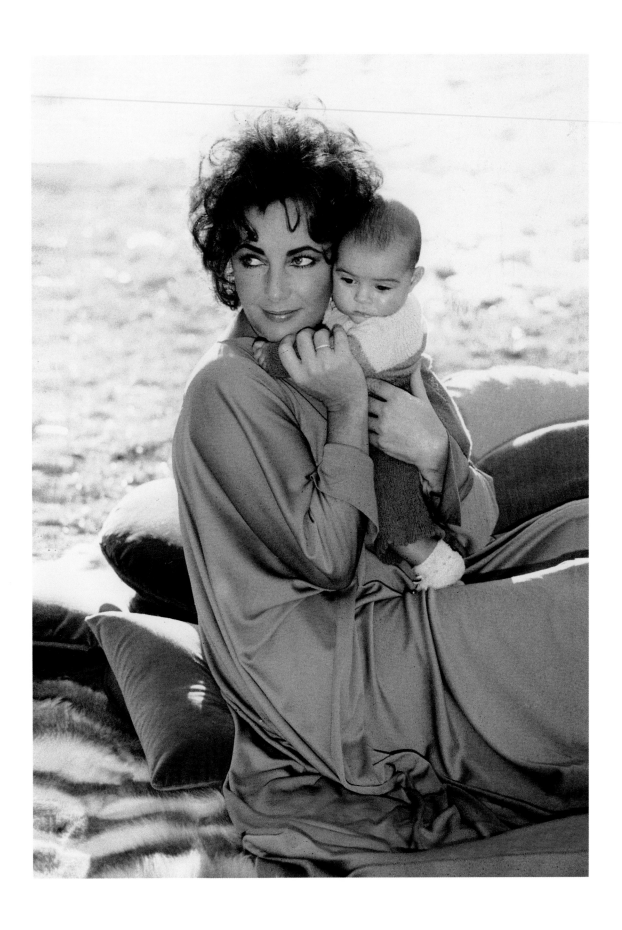

GSTAAD, SWITZERLAND, 1970. THE MOST BEAUTIFUL GRANDMOTHER IN THE WORLD WITH BABY LEILA WILDING.

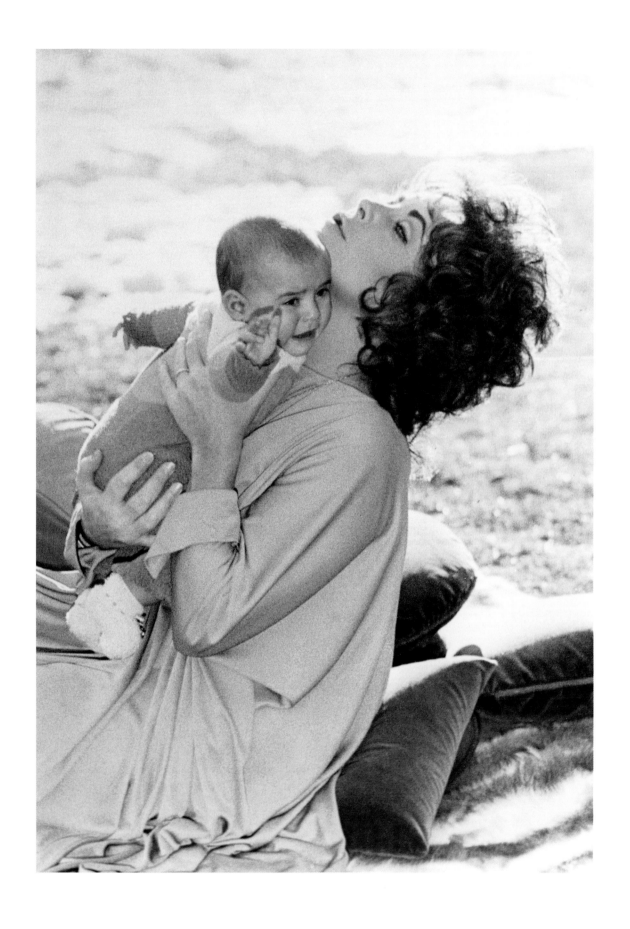

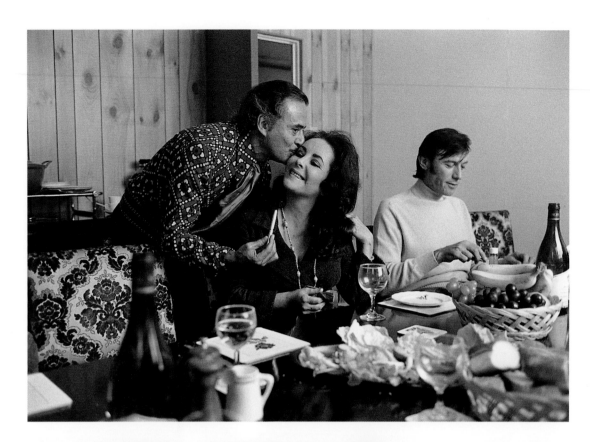

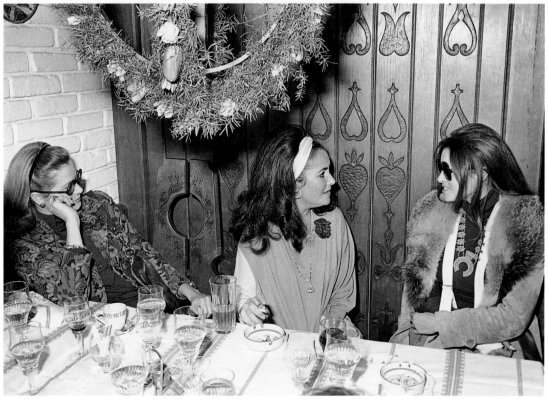

top LONDON. WE ARE AT THE STUDIOS OF ELSTREE, AND ALEXANDRE, THE FAMOUS HAIRSTYLIST AND ELIZABETH'S GREAT FRIEND, ASKS HER FOR AN AUTOGRAPH. NEXT TO ELIZABETH IS LAURENCE HARVEY, THE BON VIVANT.

bottom PARIS. THE THREE MOST PUBLICIZED CELEBRITIES OF 1972—THE PRINCESS (GRACE KELLY), THE SUPERSTAR (ELIZABETH), AND THE SEX SYMBOL (RAQUEL WELCH).

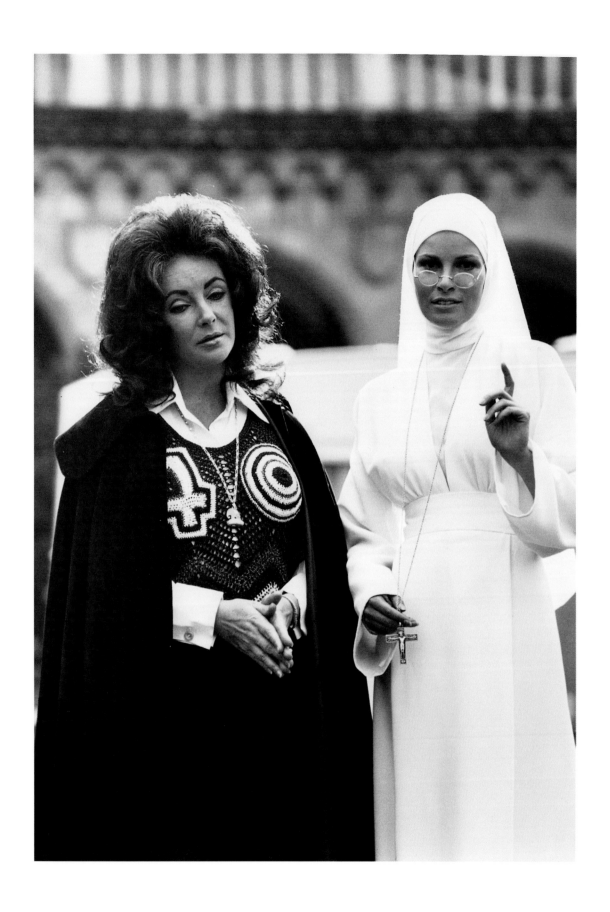

BUDAPEST, FEBRUARY 27, 1972. ON THIS DAY ELIZABETH IS FORTY YEARS OLD,
BUT SHE CARRIES HER AGE LIKE A GODDESS. FURTHERMORE, SHE ADVERTISES HER AGE
WITHOUT INHIBITIONS. SHE'S IN THE COMPANY OF RAQUEL WELCH, WHO IS, THIS TIME,
COMPLETELY COVERED FROM HEAD TO TOES.

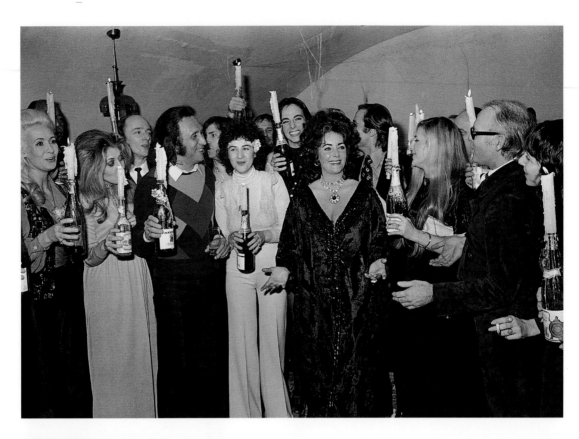

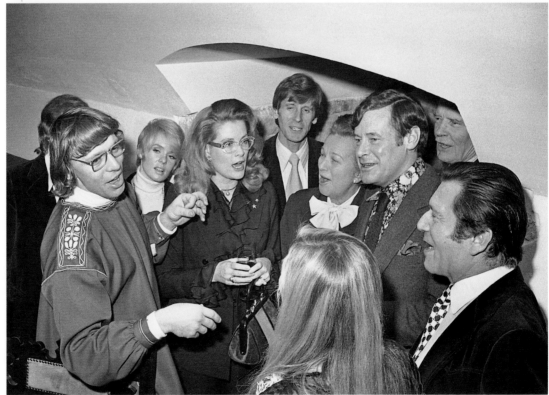

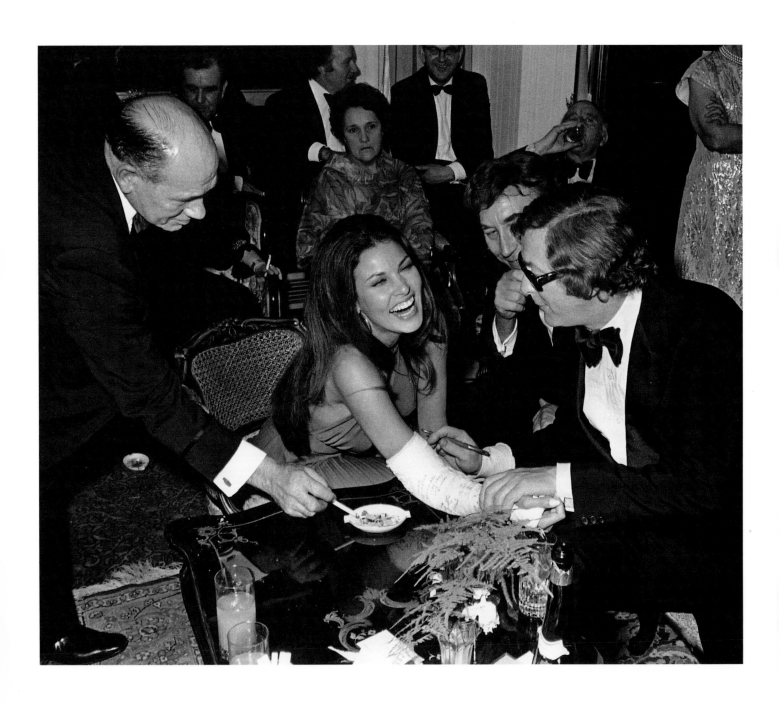

HOTEL CONTINENTAL, BUDAPEST, FEBRUARY 27, 1972. AT A SPECTACULAR PARTY FOR
ELIZABETH'S FORTIETH BIRTHDAY, NO ONE IS MISSING FROM THE GUEST LIST: TAILORS,
JEWELERS, BANKERS, PRODUCERS, DIRECTORS, WRITERS, ACTORS, PRINCES, PRINCESSES,
AND ME. AND ALL IN CHORUS: "HAPPY BIRTHDAY!" LATER, MICHAEL CAINE AUTOGRAPHS
RAQUEL WELCH'S CAST.

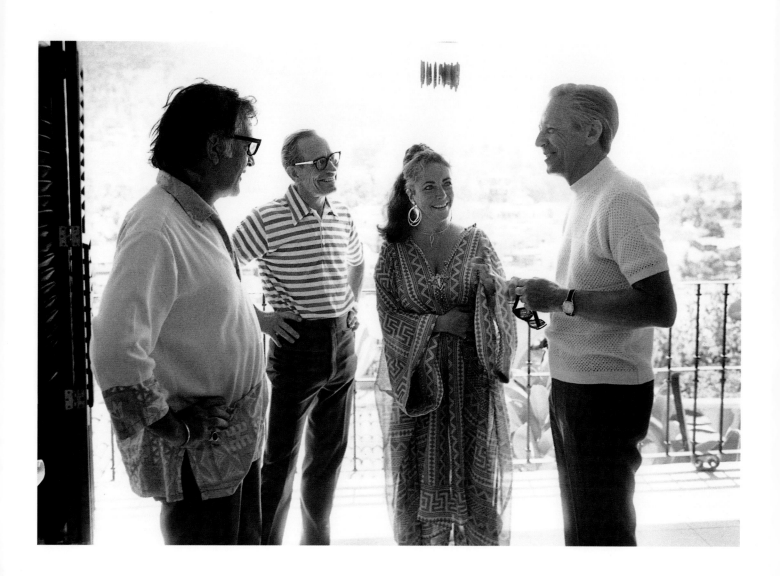

Puerto Vallarta, Mexico, 1971. I was going into their house, where I was their constant guest, when two tourists courteously asked me if they could see Elizabeth. One of the two timidly told me his name: "Tell her that Charles Schulz would like to meet her." Elizabeth was very happy. She loved Charlie Brown's philosophy.

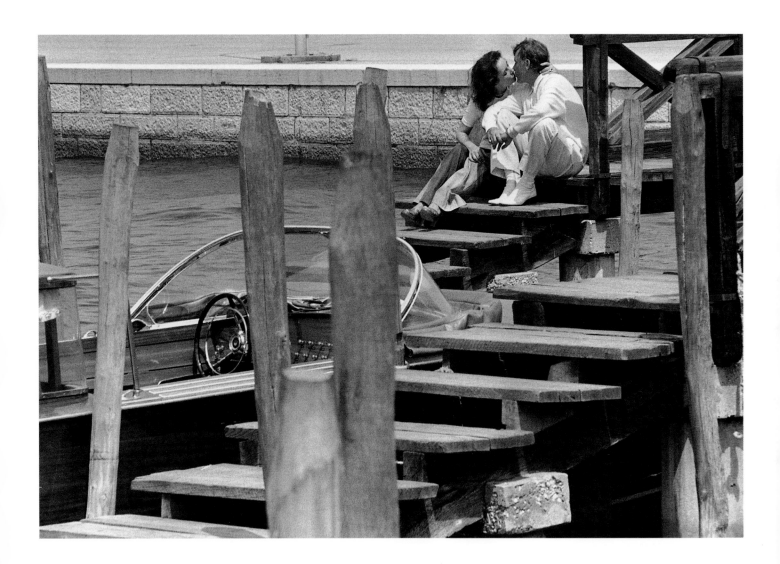

VENICE, 1975. EIGHT MONTHS AFTER THE FIRST DIVORCE. I WANT TO BELIEVE THAT THIS KISS
LED THEM TO THE SECOND MARRIAGE. "IO AMO QUESTA FOTOGRAFIA." I WOULD LIKE TO SEE
THEM TOGETHER AGAIN. "MAYBE. WHO KNOWS?"

following page

FLORENCE. "ELIZABETH'S MYTHICAL BEAUTY REFLECTS EVERYWHERE."

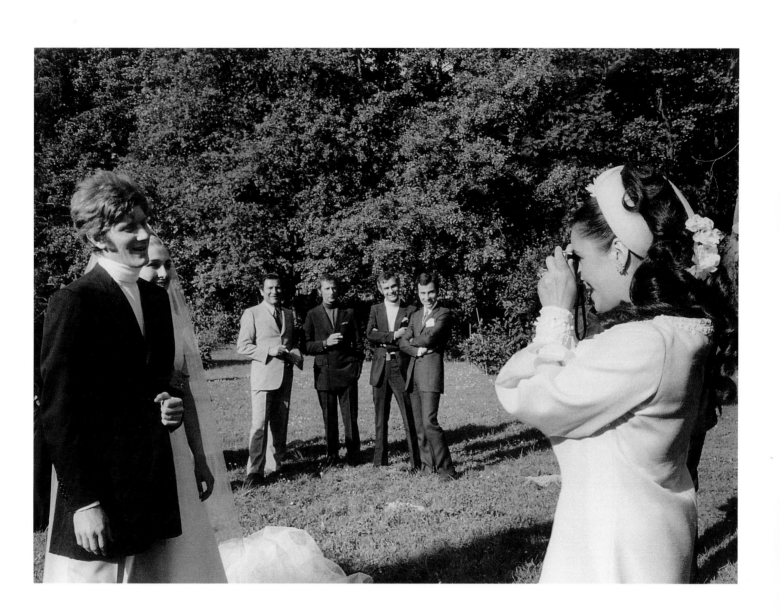